# WAKE for the ANGELS

# WAKE for the ANGELS

paintings and stories

MARY WORONOV

JOURNEY EDITIONS

BOSTON • TOKYO

First published in 1994 by

JOURNEY EDITIONS

153 Milk Street

Boston, Massachusetts, 02109

Library of Congress Cataloging-in-Publication Data

Woronov, Mary.
    Wake for the angels : paintings and stories / Mary Woronov.
        p.   cm.
            1. Woronov, Mary--Catalogs.   I. Title.
ND237.W864A4   1994
759.13--dc20                                          94-20865
                                                     CIP

ISBN 1-885203-00-4

Edited by Denise Bigio
Designed by Tim Stedman
Photography by Paul Ruscha

3579108642

Printed in Hong Kong

for

CAROL  E.  WORONOV

# ACKNOWLEDGMENTS

This book would never have been done without the help of my friends: Cindy Patterson who helped me form the original idea of the book; Amy Inoui who gave me her computer, then her printer, and then her fax; Jonas Livingston for listening early in the morning; Tim Stedman who wanted to do the design no matter what, and that includes his assistant, Todd Gallopo; Paul Ruscha for photographing my paintings, and most of all Denise Bigio for her dedicated editing and ability to get the best story out of me.

My thanks also to Mrs. Ann Janss, Happy Price, and Danna Ruscha for encouraging me to write, and to my publisher Peter Ackroyd for giving me the chance to do a book like this.

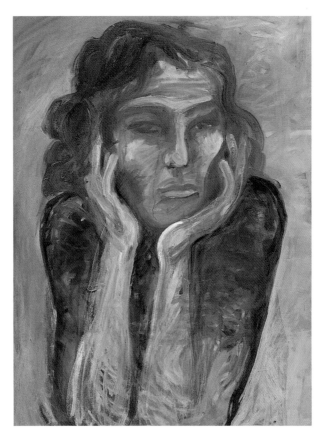

Self Portrait   Oil   *36"x 48"*   1990

# INTRODUCTION

Like most people who end up in L.A., I am a transplant. In 1973 I moved here for what seemed like sound professional reasons: having received no encouragement in New York for either my painting or my first novel, I figured all I was good for was acting, so I came to Hollywood.

L.A. scared me at first. It was so full of blank space, and my response was to fill it up by painting colorful and increasingly nightmarish narratives. In New York I never used color, but here I couldn't use enough, and although I was supposed to be acting, all I did was paint. When I met other girls we would compare notes while fixing our hair or sharing a joint in restaurant rest rooms: no one seemed to have a clear course, and the air was packed with dreams trying to find bodies to crawl into.

Of course we blamed L.A. for our confusion. She wasn't what she pretended to be: for all her promise of paradise her real weather was fire, and the glitter on her streets just crushed glass from some car wreck. Yet Los Angeles is the only muse I have ever taken seriously, and she is the subject of this book, not Mary Woronov. Although I do not paint from real life, using actual models, still the paintings emerged like an eerie hologram of the city's subconscious, vaguely familiar but with dream-like exaggerations.

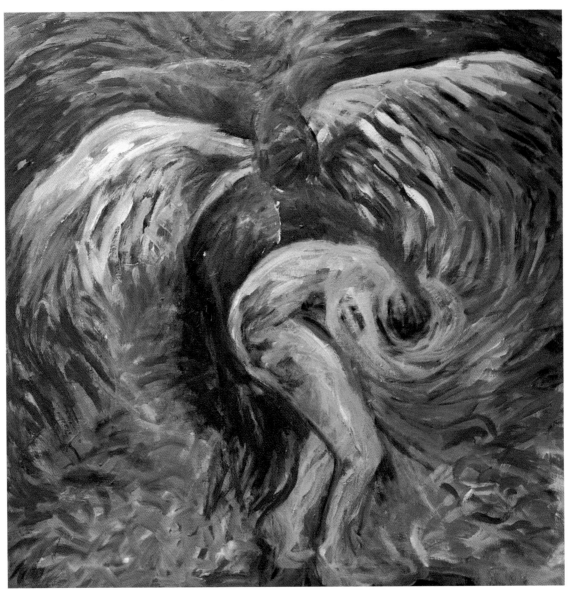

Wake For The Angels   *Oil   36"x 36"*   1991

Like a movie, this book has picture and sound.  The paintings span two decades, ranging from my early infatuation with L.A.'s freeways and eternal sunshine to the addiction I feel for her even now after knowing her other face, an apocalyptic skull grinning from under the commercial make-up.

The text came later, when Peter Ackroyd asked me to do this book.  I wanted the writing to illustrate the pictures, instead of the other way around, so looking at each painting I wrote a short work of fiction to go with it — fiction I found growing like weeds in the emptiness of L.A.  Together these stories and paintings lie at the intersection of imagination and memory.  I would call them a diary of L.A., but I would not call them autobiographical.  My life has been great but not quite so twisted.

Mary Woronov
*Los Angeles, 1994*

Tommy, My Kid Brother   *Acrylic*   24"x 24"   1978

*I*

FAMILY

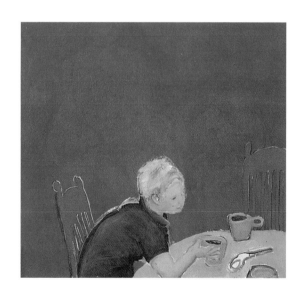

M**Y** MOTHER FELT COMPELLED to sing a lullaby to me at bedtime. Thank God she was aware of not having a good voice and only sang one song, otherwise I would have definitely been deformed. As it was, my brain was seriously warped by this mournful melody. The lullaby, *Speed Bonnie Boat*, was about Bonnie Prince Charles' escape to the Isle of Skye where he was safely hidden from the enemies who wanted to kill him. I figured that Mom was preparing me for the worst, that there was a curse over our heads waiting to burst and cover us in blood. On the nights when the wind was busy trying to

*Boat Ride* unlock my windows, I heard the enemy looking for me, using the moon as a searchlight, turning the clouds into bushes along the sky trail. His horse hooves pounded down the highway into the tiny vein under my jaw. I spent the night packing imaginary suitcases, deciding which toys I could take and what I would have to say good-bye to.

Asleep, I dream of the boat ride across the black licorice water to the stone tower called Skye. There is always a different man guiding the boat while my mother stands at the rail reading letters about things she'll never see again. I'm not allowed to take my dog with me, but that's O.K. because I was never allowed to have a dog anyway. This dog stands on the dock as we pull away. The water swells up and down between us and I can hear the horses in the sky, just under my ear. It isn't until we're in the middle of the ocean, and the dog is small and far away, that he begins to bark, trying to tell us that someone else is on the boat — the enemy is with us.

So when my mother did announce, with tears in her eyes, that we had to leave, I did not cry. I told her right away what to pack and what to leave behind. I knew we had to be out before he came back, and when my tricycle didn't fit in the taxi I watched it get smaller and smaller on the sidewalk as we pulled away. She said we could send for it, but I told her, no Mom, let the horses eat it.

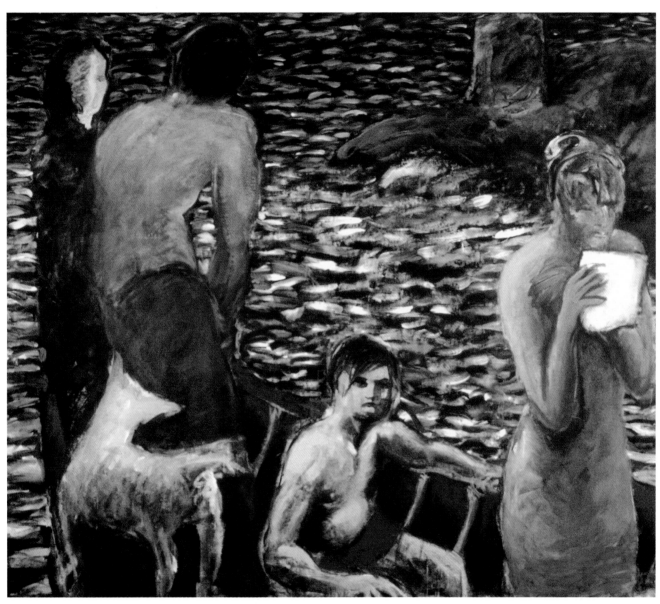

Speed Bonnie Boat   *Acrylic   89"x 76"   1984*

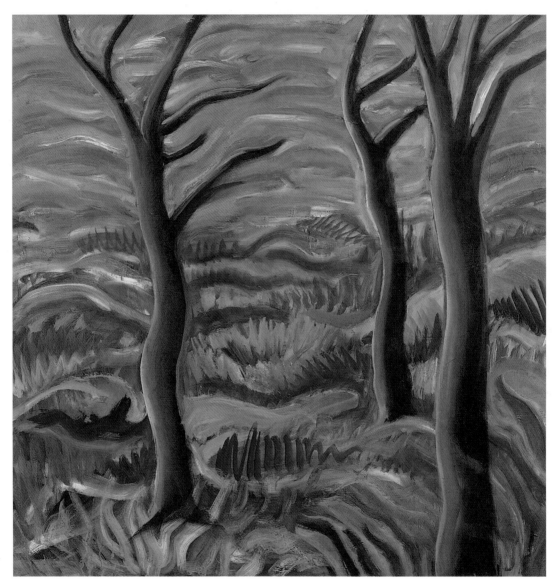

Three Trees   *Oil   36"x 36"*   1989

THE PRIVATE BOARDING SCHOOL called Edgewood actually was on the edge of a darkly wooded area. These trees frightened me. There were three very tall elms that led the rest of the swaying forest behind them. Their black branches grabbed at the wind like the arms of ancient witches, and their trunks, unflinching in storming rain, seemed to be slowly moving at the rate of a growing bone, across the lawn towards the gothic structure I was now to call home.

I had been sent here because my mother had remarried and needed time to adjust. The postcards said that most of their adjusting was taking place in Europe, so I had no way of telling her about the advancing trees. At the end of October, when the trees were removing their leafy camouflage, Mom called to say she was coming up to help make me a Halloween costume like she used to do. She sounded nervous on the phone and when I saw her I could tell they had a lot more adjusting to do so I might be here quite a while. We tried to cheer each other up: Mom made me a witch's costume out of the orange and black crepe paper she had brought with her, and when I showed it off to the headmistress, and all she had to say was that most little girls wanted to be princesses, I told Mom that she loved it. Later when I

*Tree*

was telling Mom about the trees, she said I was wrong, and before she left we walked across the lawn together and she showed me how to hug them. She looked very beautiful with her arms around the tree.

That evening I skipped dinner and went running across the grass to my three new friends. Their great black trunks loomed out of the ground waiting for me. I held up one hand just as the wind came rushing down the hillside and they raised and lowered their skeletal arms, dropping final leaves from their fingertips. "She's gone," I whispered to them, "and it's the fault of the witch." "Kill the witch," they murmured in the wind. I pulled out the crumpled paper costume and with a stolen dinner knife I pinned it to the ground between the trees. "She has to be punished so I want you to keep her out here all night, as a prisoner." "Prisoner, prisoner," they moaned above me, clacking their branches, and one by one I hugged them good night.

Tree Storm   *Oil*   36"x 48"   1989

**"CHARLEY COME HERE.** Now stop crying, I wanna tell you something. I used to have this dream all the time about a family where the mom and the dad were always yelling, but I couldn't tell if they were fighting or making love — and the child with them is about to cry, but he never cries. I keep on thinking he's going to, but he doesn't. Anyway, I went to a spiritualist and she said the child was me and I should let it cry. But I could never understand why the child was a boy. Now I know that dream wasn't the past. It was the future. It was sent to me by fate and the little boy is you. So I want you to be good and don't cry. Your daddy and me are going to use the room for a while, so I don't want you knocking on the door, you hear me? Now take this change and go get dinner out of that candy machine down the hall. Go on, I used to do it all the time and it didn't stunt my growth any. You can watch the TV in the lobby and if you get tired sleep in the car, O.K. honey? Now be good, kiss Mom good night."

*Candy Bar Inheritance*

## Violet

I CAN'T STOMACH breakfast any more. Every morning Mom ends up hitting my kid brother in the head because he won't eat his eggs. His eyes blame me from across the table (normally I eat his food for him), but I can't eat those eggs. He puts syrup on them thinking they'll turn into pancakes (he's only seven), then he can't eat them, then she screams, then he cries, then she hits him, then we go to school. It's giving me an ulcer and I'm only fifteen. I can feel my stomach grinding up inside me on the way to school, while Tommy trots along beside me completely happy — he's like that, he has the attention span of a mouse. If I turned on him and yelled, "Don't you remember how you were sobbing twenty minutes ago?" he would just look at me in that baffled hurt way. So I don't yell at him, I just grind my teeth, and plan on how I'm going to beat up Valerie Windthorpe during my lunch break. I'm going to take her head in both my hands and smash it into the blackboard, and she's going to look at me in that hurt baffled way as I hit her again. Valerie is my best friend — that's what makes this daydream particularly satisfying.

It wasn't just a daydream. I did it. Right in front of Mrs. Eagles, the geography teacher. She just stood

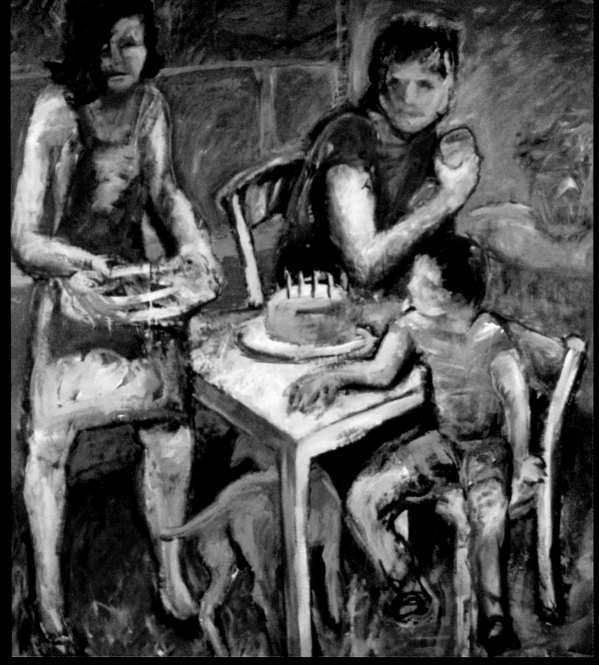

Birthday Party I    Acrylic    70"x 77"    1984

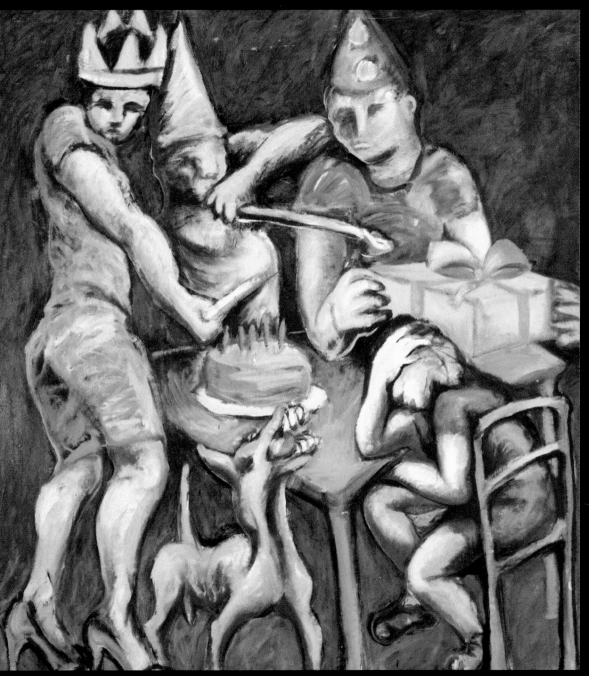

Birthday Party 2    Acrylic    70"x 72"    1985

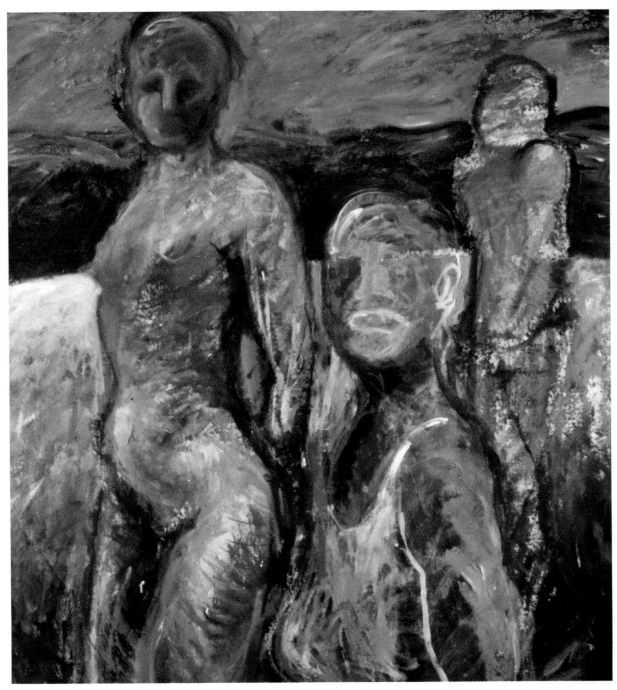

White Trash  *Acrylic*  70"x 75"  1983

there with her mouth open, while I mashed Valerie's arm with the desk top not once but twice before I threw her teeth first into the blackboard. I don't think Valerie will ever be my friend again — she didn't know what hit her, but I do — it's this big black dog that sits in my stomach growling and grinding away, until she can't stand it and attacks whatever is in front of her. I've named her. I call her Violet, for violence.

I am just becoming aware of the animals that share my head with me — it's a regular zoo in here. Most of my neuroses are in rodent form except for the obvious sexual reptile. Every time I find a new one I give it a cage and a feeding schedule. Violet was the first. Maybe I got her when Mom used to hit me when I was Tommy's age, maybe Tommy's going to get a dog that sits in his stomach too. One thing I know for sure is that later on I won't be allowed to let this dog off the leash and she's going to eat up my insides, make me do terrible things to myself, make me fall in love with someone I hate and hit my kids 'cause they won't eat their eggs, but right now I'm going to let her go. I'll let her bite as many people as she wants until they catch us, and put her away. I'll just tell Valerie that she can be my friend if she wants to, but Violet is coming along too.

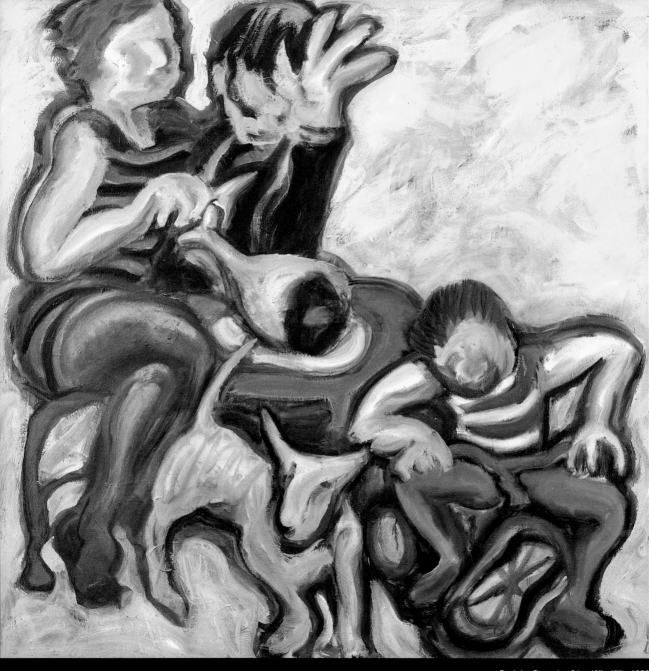

Birthday Party 4    *Oil*    48"x 48"    1990

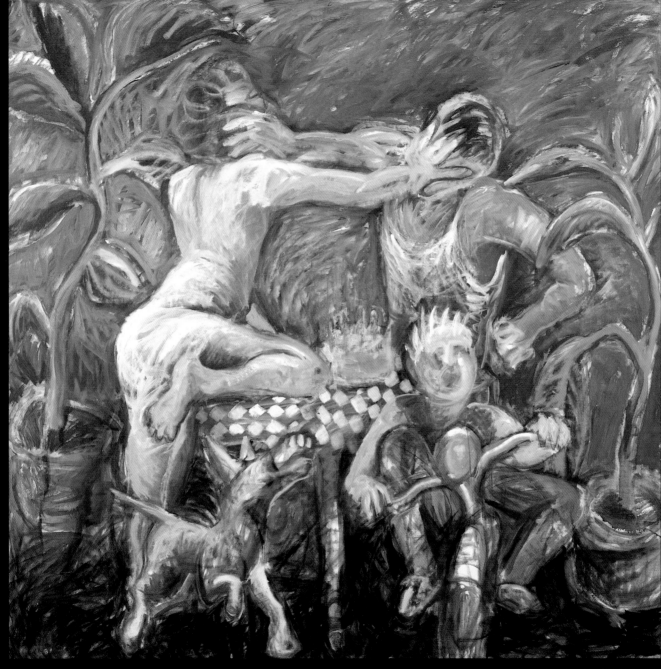

Birthday Party 3   *Oil*   71"x 73"   1986

I KNEW IT WAS WRONG, that it was making him nervous, but I couldn't help it. "How would you like it if I stared at your food while you were eating?" Mom hissed at me as we washed the dishes. "I wouldn't like it, I won't do it any more," I sniveled as she pinched my arm. But I couldn't help myself, every time we sat down to eat I'd watch the food on my stepdad's plate with zombie-like fascination. He was a real slow eater with a very little mouth. He said there was a difference between just eating and dining and I'd better learn what it was. But no matter how Mom and I tried to eat slowly, like flop-eared dogs we would be licking our plates clean way before he put down his fork. I also ate anything

## At The Table

my little brother couldn't get down in the first ten minutes of the meal. After that there was nothing else to do except to look at the food on Dad's plate. He always served himself the best pieces and took the largest helpings, even though he almost never finished them, so that while our end of the table looked like the trees in winter, his plate seemed to be a growing garden of food.

I think that, small and hungry as I was, I scared him. He just got the idea that he could never fill me up and it would be better to cut me off now before I ate everything — his money and his house, his hand and arm, and finally his heart. After months of silently watching his plate I understood that he never was going to give me anything and I knew better than to ask or expect. Poor Mom never figured it out. I knew it upset her to have such an empty plate all the time, even though she said she didn't mind. Finally my brother and I had to leave her there, at the winter's end of the table.

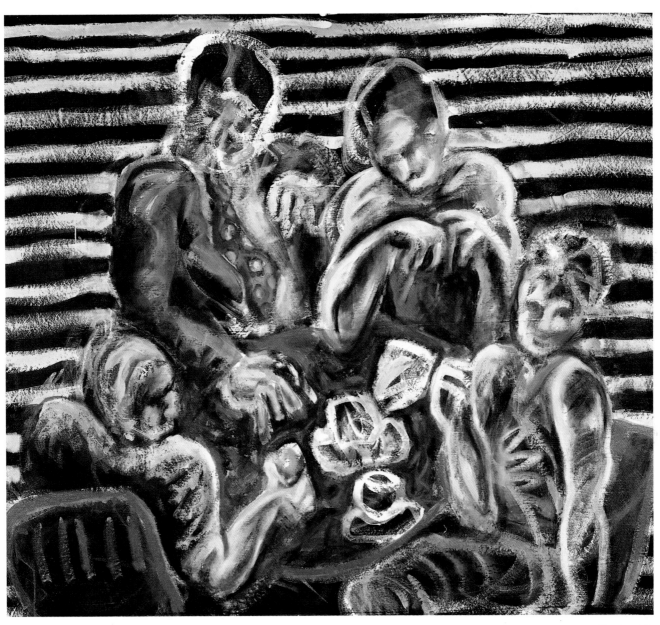

Dining Room Table   *Oil*   72"x 60"   1990

EVERY SUNDAY we had to go on a picnic. Mom insisted on it. We never understood why since no one had fun at these affairs, least of all her. (It wasn't until much later that we were told Mom was a martyr, and even then it didn't really sink in.) At every picnic she also insisted on making those sliding egg sandwiches that were so impossible to eat. The sliced eggs slid off their mayonnaise runways into the sand on the beach, into the grass at the park, and onto the red rubber car mats when it rained. I told Mom I hated her picnics. She

*Picnic* laughed at me as she climbed up on her cross where she liked to sit. "You'll see," she crowed, "you'll have them for your kids." "I'm not going to have kids," I warned her, squirting my eggs out of the sandwich and smashing them under the heel of my red tennis sneaker. For some reason that made her angry, just ruined her day she kept on saying as her fists made my head ring.

I refused to cry as the sky tilted, and the black water came rushing down the grassy hillside flooding into our tiny hearts. Tommy was no help, he could barely keep his head above the emotional ocean she was in command of. The back of my head lay on the dirt and all I could see was the yellow sky full of crows. "The blackbirds of iron-clad fate," is what my Latin teacher called them. What a racket they made, with their mocking prophesy. "You'll never leave the picnic on the hill, trapped forever in the family by the sea."

Years later, eating an egg salad sandwich on Malibu Beach, petrified in my own rotting marriage, I promise the ocean never to give Mom a grandchild she could take picnicking. Kneeling over the last bits of egg, I bury them in the wet sand and watch as the ocean sends wave after wave, trying to uncover them. Gulls hang in the air, "rats in feathers" is what my girlfriend calls them. All day she has been trying to talk me out of this abortion.

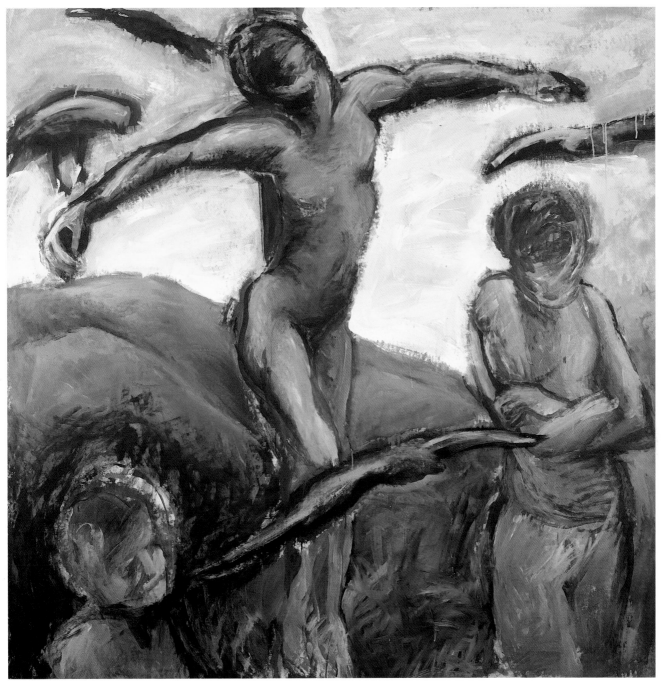

Picnic  Acrylic  68"x 68"  1984

WHEN MY YOUNGER BROTHER STARTED first grade he said he didn't like the rules I had laid down for us. He started complaining and it became necessary for me to threaten him. I told him that the sky was not just a dignified gray, that it was really a whirling mass of angry slate gray leather bat bodies and if you didn't hide or have a big sister to protect you with her metal

*Storm*

umbrella, the shifting wind could turn all that soft gray fur into a sea of pink snapping mouths, and in one fell swoop you would be nothing but a pile of bones and hair — bats didn't like hair, it got stuck in their teeth. I also had to tell him about the grass, about how it was not as pretty as it seemed to be, that below the bugs and snakes and worms, below the blood and bones of the earth, swam feelings as long and black as giant eels that could reach up and pull you under if you didn't know how to walk a certain way. I wasn't being mean. I just wanted him to be more aware, without actually telling him, that Mom and Dad were the monsters I was talking about. I knew. I could show him the scars.

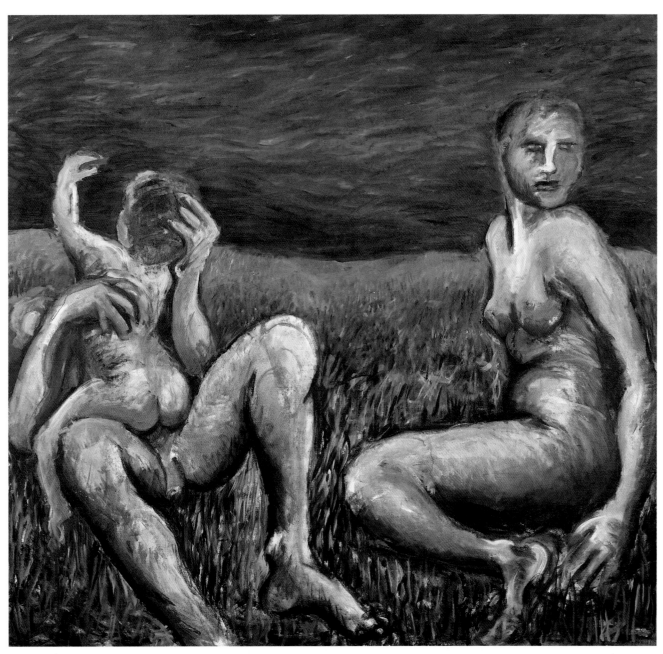

Storm   *Oil*   62"x 60"   1986

WHEN SHE WALKED in the door the first thing she did was announce that she wouldn't clean a house that didn't have a Bible in it, and true to her word she didn't even remove her hat until Mom found an old leather-bound King James version none of us had ever seen before. Viola was big and black and I had serious doubts as to whether this was going to work out: for one thing Viola looked like she could do some serious damage if aroused. Mom seemed afraid of her too. She tried to get Viola to come at the sound of a bell, and when that didn't work she nervously tried to camouflage her under a uniform and a wig. When she insisted Viola perform French service my sister and I laughed so much we couldn't eat, and rather than see us starve to death Mom gave up. I liked it when Viola acted like an American maid, when she came rolling out of the kitchen in her own sweet time with that "what do you fuckin' want" scowl

## Viola: by Tommy

so bad it made the dinner guests drop to their knees with their knuckles gone white all wrapped around their eating utensils. She was the best. The kids on the block stopped picking on me when she stepped out of the front door; one look from Viola and they backed way down. She even got my sister Lucy to stop being so mean, got her talking about boys instead. Soon she was the black core of our house — the only reason any of us were glad to be home was because Viola was there.

On December 28, Viola made another announcement. She had made enough money and she was returning to Tennessee. The house caved in like an old Halloween pumpkin. The idea that Viola didn't love us as much as we loved her was like hitting a cement wall at ninety miles an hour, and we all became severely damaged. Dad accused her of only staying for her Christmas bonus and then tried tripling her salary, but Viola just shook her head. Lucy went into a tailspin. No one, but no one, and least of all my mother, would let her wear lipstick and talk sexy about boys the way Viola did. Secretly I was relieved, my sister made me sick the way she carried on, but I was also furious. What would happen to our afternoon jam sessions where Viola played the steam iron to my virtuoso drum riffs? I felt betrayed. I had thought those sessions meant as much to her as they did to me.

When Mom started crying we all shut up. I mean we all had aches and pains about Viola leaving, but Mom was having major surgery. Poor Mom, I guess over the years Viola had been her only friend. Funny, I never realized that she didn't have any other friends.

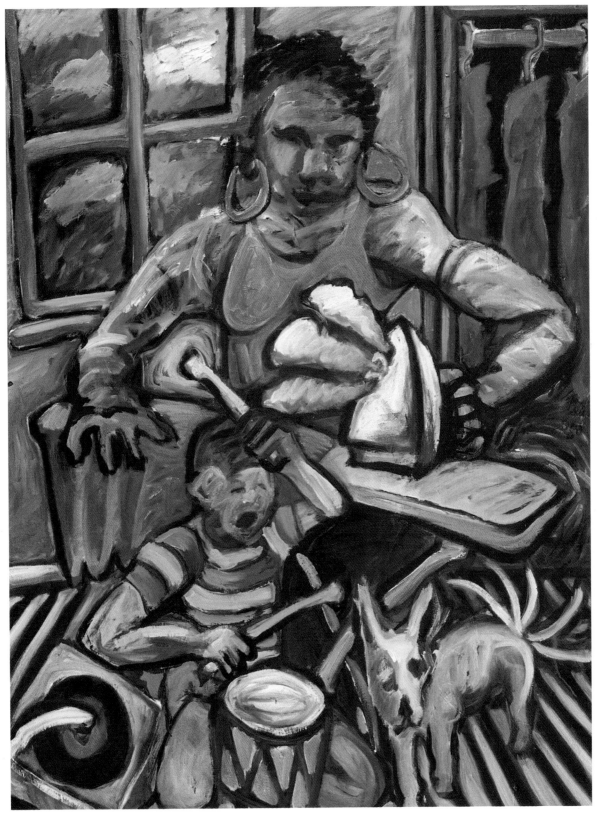

Viola  *Oil*  36"x 48"  1991

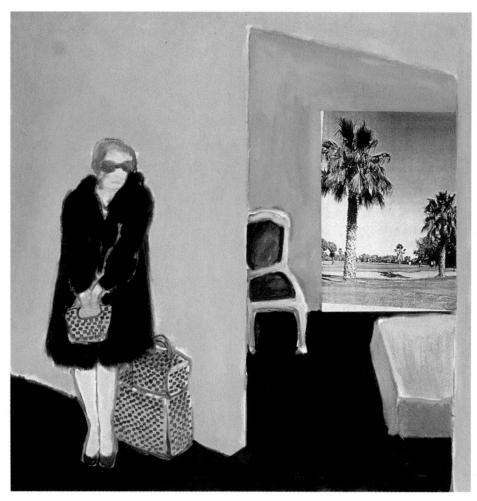

Fur Coat In Florida    *Collage    36"x 36"*    1980

My MOTHER wasn't really into looks. She stressed sensible ugly shoes and she let us wear blue jeans when we were traveling because her mother had

*Mother* always made her dress up for trains and strangers. Nevertheless she insisted on wearing her mink coat at the most incongruous times, even after moving to sunny Florida. Like a hard-earned scalp she dragged that thing everywhere, and to our embarrassment she wore it the day Daddy died.

The hospital was a big concrete and glass affair. I flew in from California and the minute I saw Dad I was on the phone to Paris telling my brother to hurry. It was all happening so quickly the only thing Tommy and I could do was make sure he didn't die alone, and towards the end my brother and I refused to leave his room.

Death entered while we were watching *Star Trek*. We rang for the nurse who patiently told us that he would die in stages — first his brain would go, then his body and finally his heart. I told Tommy to get Mom. Bristling into the

room, her fur electrified, she immediately started cleaning up, hurriedly packing his things as if they were late for a train. Tommy let out a strangled whine of embarrassment as she tried to stuff Dad's hair dryer into his shaving kit. Looking at Dad I hoped that he might thankfully already be dead, when Mom grabbed his hand and started to wrench his ring off his finger. She stopped when his eyes unexpectedly opened and we stood frozen before him. He seemed different, like an alien pretending to be our dad. The unfocused eyes searched the room, trying to see, then closed as he made a noise that came from somewhere outside, already in the ground, far away, a noise that said 'leave me alone,' and pulling his ring out of Mom's grasp he brought it to his chest. That was his final gesture to us. We stood for some moments waiting for more, but that was it, that was the last motion he ever made. Like I said to Tommy as we struggled to put Mom into a cab, it was kind of typical of his whole life, he never liked giving anything up. He had died without saying good-bye to either of us.

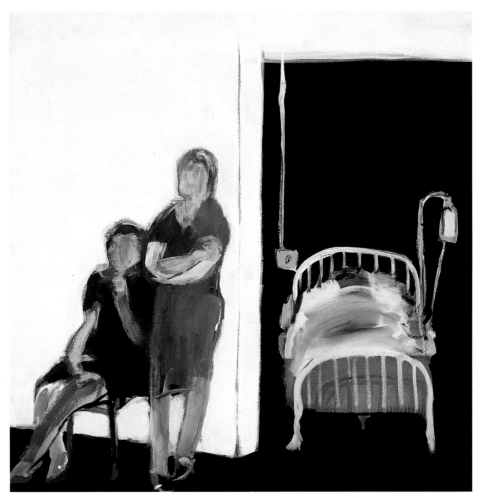

Hospital Room I   *Acrylic*   *36"x 36"*   1980

FLORIDA, THE VERY NAME makes my brother and I cringe in fear and squeak like mice — no, no, we don't want to go.  Now we have a pact always to go together, that way when it becomes too much we can go with each other to Carvel in the middle of the night, and sit for hours nursing our ice cream cones, watching the cars go up and down Highway 95.  Why do we come to this graveyard state?  Because it's where our relatives migrate to die.  It's where Hanna and Eve drag their clownish husbands in plaid golf pants and beeping pacemakers to wave good-bye to each other, and it's where Harry and

## Florida

Marvin prop their crone wives up to watch the last poisonous pink sunset.  It's where our mother waits for death, either hers or her mother's, it doesn't matter which, and it's where our grandmother at ninety-three yells down the corridors of the Sunshine Nursing Home, "I have no intention of dying until you get me a private room!"

My brother and I sit at Carvel with the traffic whizzing by, monitoring each other for symptoms of that fatal genetic disease, Mommyitis.  In the middle of my sentence he'll shriek as if his tail were caught in a mousetrap.  "Stop, that's just how Mom sounds, you sound just like her," or he'll suck on the bottom of his cone, and I'll make a face like I've swallowed a box of rat poison.  "Stop it, that's just how you-know-who eats her ice cream."

We used to come out here and smoke a joint, make big plans, but now we just eat ice cream.  It's hopeless, pretty soon we'll be golfing in plaid pants and staring aimlessly at the salmon-colored sky.  Tommy starts rocking back and forth and waving at the traffic like he's addle-brained.  I can't help myself, I start laughing.  Soon we're both laughing and waving.  He's right, what else is there to do here?  The people smile and wave back at us from their sealed air-conditioned cars.

Good-bye Harry, Good-bye Sofia, Good-bye Ethel, Good-bye Arthur
Acrylic   49"x 64"   1983

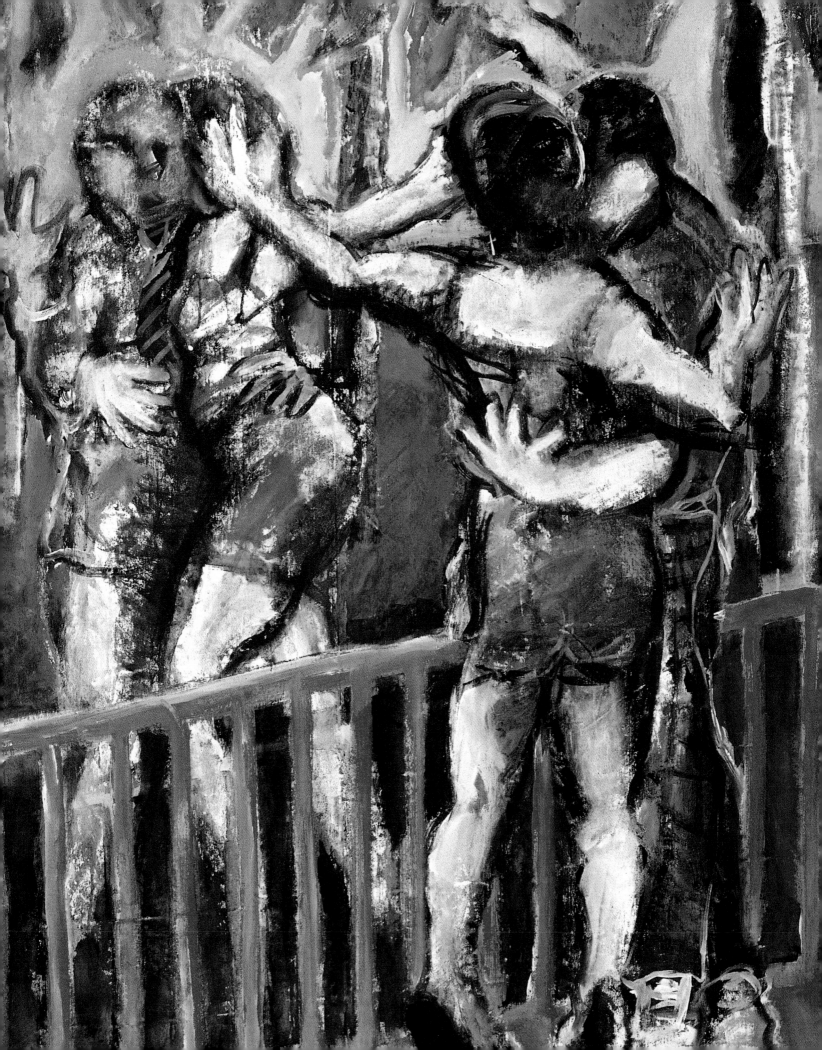

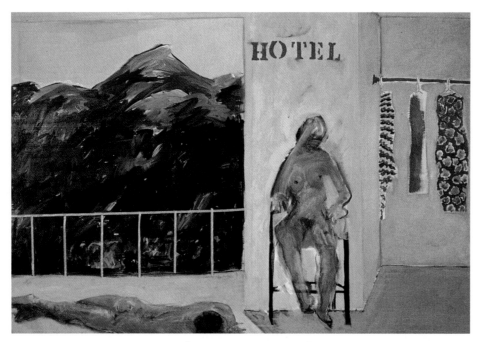

HAVE YOU EVER NOTICED how you'll be in a hotel, on vacation, with a lover and a view, and you'll be lying in the sun when the past drags you back. The walls of the hotel crumble away as the red dirt of Chapel Hill is bulldozed in by your brain.  Lying on the beach in Mexico you realize that Nana has just turned the sprinklers on like she promised she would if it got too hot so that you and your kid brother could play in the circle of raindrops. Even though you are sitting in the lobby of the Lowell in New York when you hear your name called, you're still on the porch in North Carolina sulking because you had to baby-sit your brother and you just didn't see how you were ever going to have the time to grow up.  Now as the snow falls and you realize you're stuck in O'Hare for the night, you would give anything to smell that red dirt — again on your shoes, on the dogs, on the grass as it stretches over the hills and ripples in the distance from all the heat.  You wish the old dog were still alive, and your brother never grew past three foot four, and most of all you wish you could be that bored again, when the days of red dirt stood still and you had nothing better to do than scratch the mosquito bites on your legs.

*Vacation*

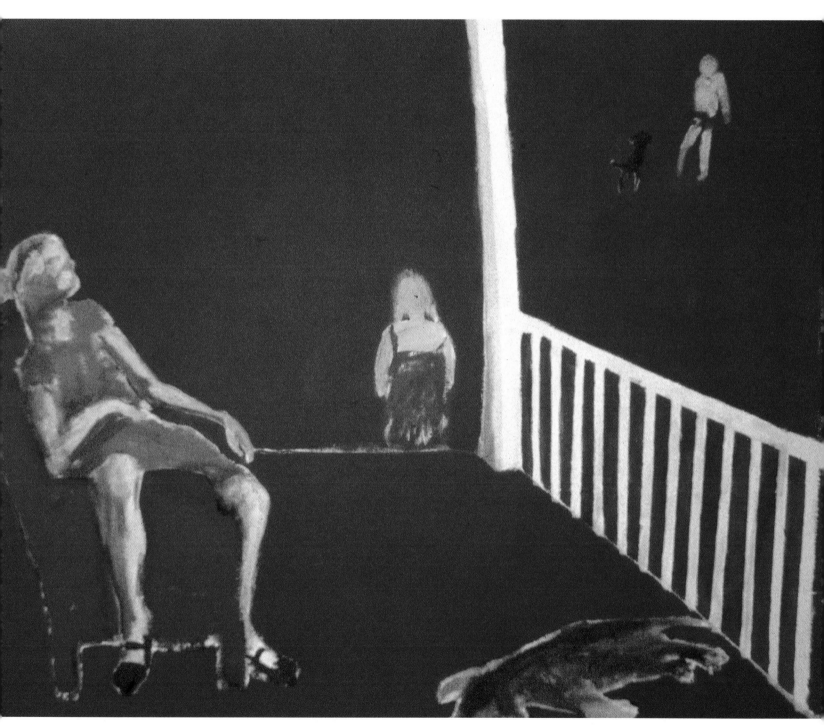

Red Dirt Day    Acrylic    66"x 52"    1980

31

On The Rug    *Acrylic    36"x 36"*    1982

# 2

# m A R T H A

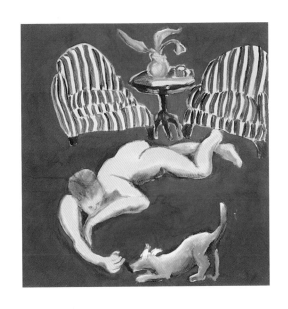

THE FIRST PERSON Martha saw every other morning at nine o'clock except on weekends was Alan — no one ever remembered his last name because no one ever used it — everyone just called him Alan, which is pretty impressive if it puts you on a first name basis with the heads of movie studios and record companies. Let's just say it's very helpful for when you get one of your projects together, and Alan was working on a project, a book on tennis technique with a twist. You see, Alan taught tennis, but only to the very rich. Well, actually, just to the wives of the very rich. Alan's tennis was pretty average. In fact, Alan's real job was occupying wives while their important husbands were fooling around on them, sort of a baby-sitter for the permanently bored and neurotically suspicious. Alan's instructions usually ended with, "Keep her off my back, will you, Alan?" or, "Take care of her, she's a pain in the ass when she's not getting any." A month after their whirlwind wedding, Martha's husband suggested she take up tennis.

In the back of her mind Martha knew why her husband had married her. She had the perfect look for the furniture in his new home — even his decorator seemed to think so, the way he would murmur "perfect" every time she sat down in one of

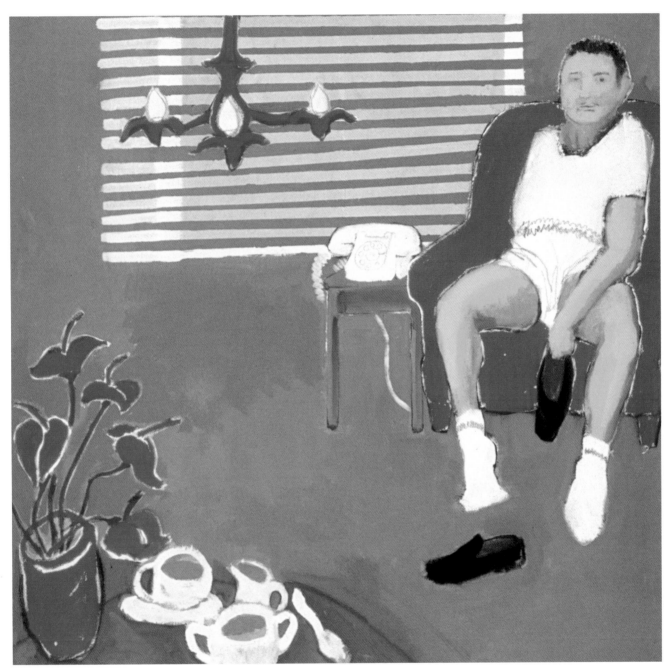

Tennis Pro   Acrylic   50"x 48"   1978

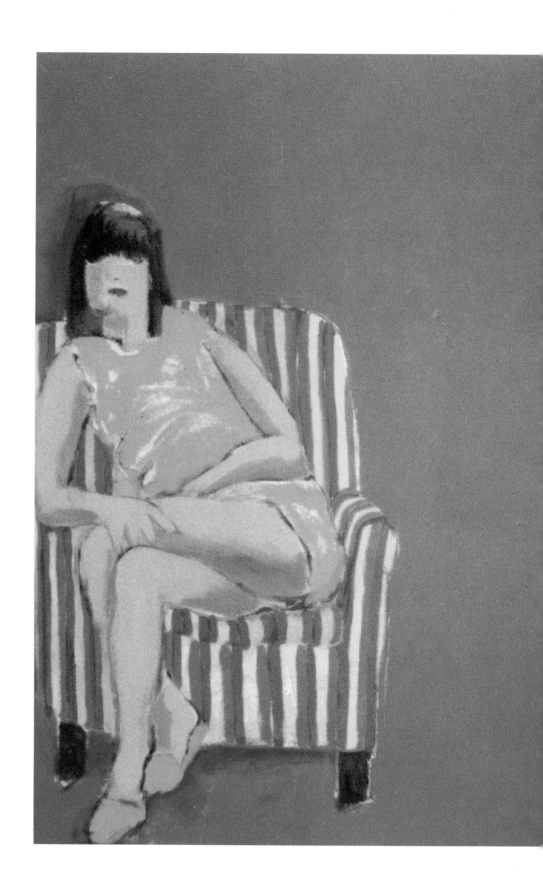

the striped water silk chairs they had chosen.  After a while she felt as if she were being examined for flaws by every light bulb in the house, and she began paying excessive attention to the way she dressed.  As the chairs were replaced with more valuable period pieces, she began to feel a growing competition with the furniture and her efforts at grooming took on the ferocity of a reupholstering job.  She had her tits done twice, her nose reshaped, and silicone injected into her lips, so that somewhere along the way she completely misplaced her own face.

She knew the look they wanted — it was that sort of WASP old money look — a look that you had to be born into.  But her husband, a kid from the Valley, was convinced he could buy it, and she was a girl from an ugly situation in Ohio who thought it was her childhood dream.  As a dream it was cute for a five year old, average for a twenty-five year old, and rather desperate at thirty-five.

Now at three in the morning she would find herself rattling around her dream home quite alone, and there didn't seem to be much fulfillment going on here.  Oh, there were plenty of Quaaludes, television, Placidyls, and several self-help books having to do mostly with crystals and out-of-body experiences, but quite frankly the only real contact she had was with the Persian rug downstairs, where she was in the habit of passing out on her way to the built-in bar.

Martha's mother and her mother before her were cannibals.  They both lay in wait in the sunny swamps of Tampa, Florida — big brown alligators with hooded yellow

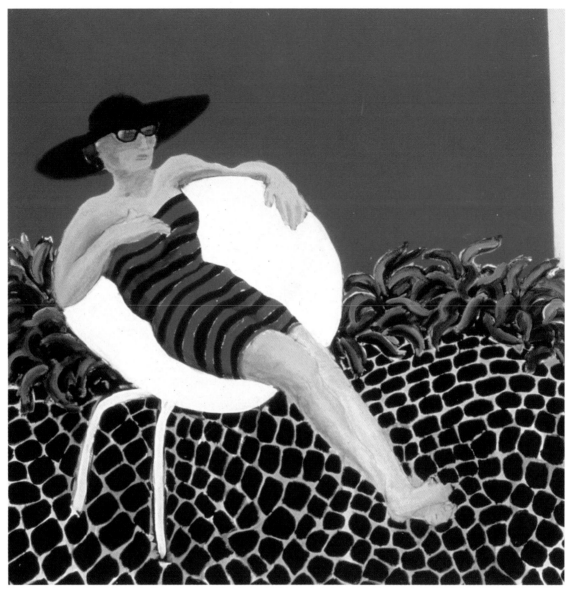

Floridian Relative   *Acrylic*   48"x 48"   1976

eyes, occasionally fighting amongst themselves to keep in shape.  Every day they called Martha and reminded her that when she failed she could always come home, that they would be waiting; and she would picture their long teeth and short arms tearing her flesh to bits with the intense muscular pleasure of born predators.  The last time she visited her mother she woke up in the night to find her poised by the side of her bed, staring at her hand that lay above the covers. In horror she watched her mother's jaw unhinge, displaying endless rows of sharply pointed teeth like the rows of newly planted corn poking through the black dirt of the Ohio fields, which stretched off the road and into the distant

hills of her childhood.  The next morning Martha was on a plane back to L.A ,
determined to make her marriage work.

At Martha's request her husband replaced her tennis lessons with therapy
sessions.  She'd complained that Alan had made several passes at her which she
found absolutely humiliating, but in the shrink's office she confessed that after
coffee in Alan's motel room she had been strangely attracted to him, but he
hadn't been able to get it up.  The shrink offered her tea, explained a little bit
about projection, and asked her if she would like to talk about her own sexual
problems.  When Martha complained to her husband that her shrink had made a
pass at her that she found deeply offensive, he considered for a moment, then

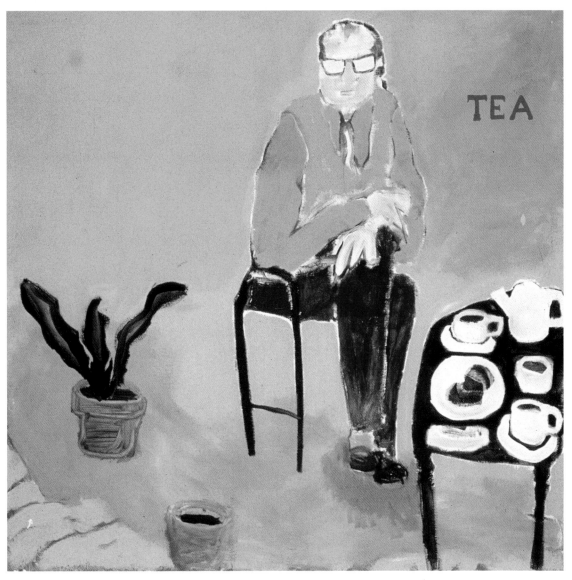

Tea   Acrylic   48"x 48"   1977

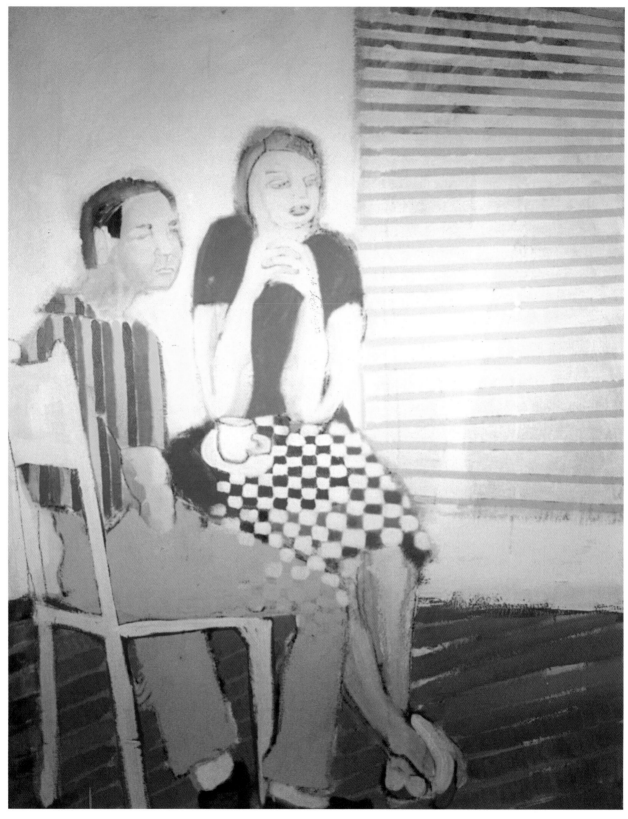

The Date   Acrylic   40"x 52"   1978

taking her hand tenderly in his, asked her if she would like to take up horse back riding.

Martha's hair colorist had a better idea. "Have an affair. Your husband doesn't fuck you any more, he's in the office morning noon and night — who are we kidding here? Don't you think every woman in your health club is balling someone on the side? You can't not have sex, it's not normal. You gotta get laid." They became the best of friends, shopping every day in the malls. Martha insisted on putting everything on her card, and in return her hair colorist insisted on setting her up.

Martha's affair was offensive and humiliating but this time she tried not to complain. Her lover, however, complained continually, and mostly about money. He was in the process of getting Martha to buy him a new car when he received a threatening call from her husband. The very next day Martha was unceremoniously dumped by her lover, leaving her already fragile sexual ego shattered.

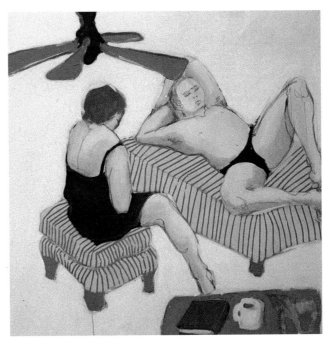

The Affair   *Acrylic*   48"x 48"   1978

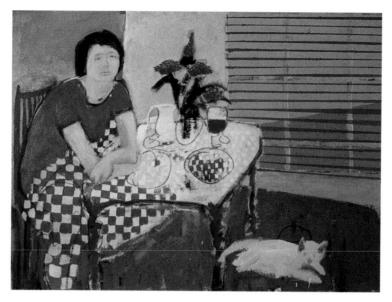

Plotting Revenge    Acrylic    48"x 36"    1982

October 1, two girls sat in Martha's living room. One was her husband's recently fired secretary, the other was the secretary's lover. In detail they described her husband's affairs, starting with the actress he'd had the day after their wedding, ending with a photograph of the model he was currently practically living with, and including somewhere in between the phone number of the whorehouse where he had a running and well used account. It took about two hours and fifteen minutes. Martha recognized the photo and remembered that the woman had been very nice to her when they had met. She then excused herself and went to bed for three days.

Occupying herself with dreams of revenge and endless interior dialogues she lay there until her mind turned around like a rabid rat and bit her in the brain. Infection set in and that ever so slight step was taken over the edge. She became positive that the dykes were lying and that the reason why her husband wasn't fucking her was because he was gay.

The next morning she sent several letters to his business associates warning them of his homosexuality. She noticed that whenever he was with his men friends and she walked into the room their conversation stopped, and when she left the

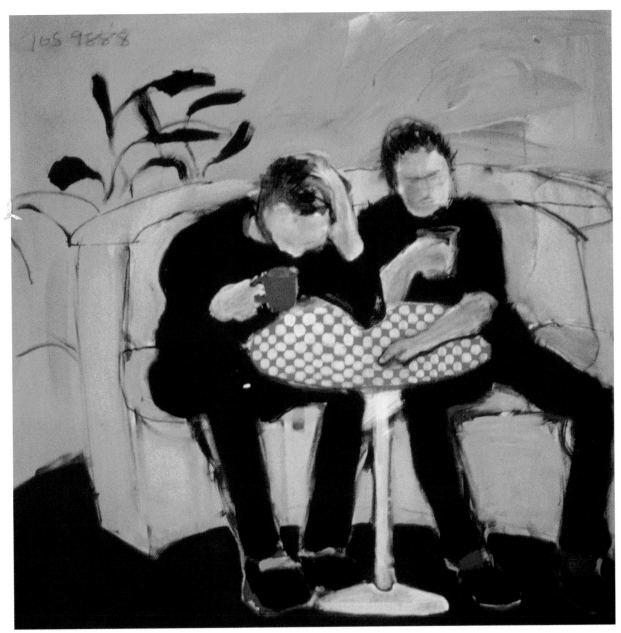

The Boys   *Acrylic*   *36"x 36"*   1982

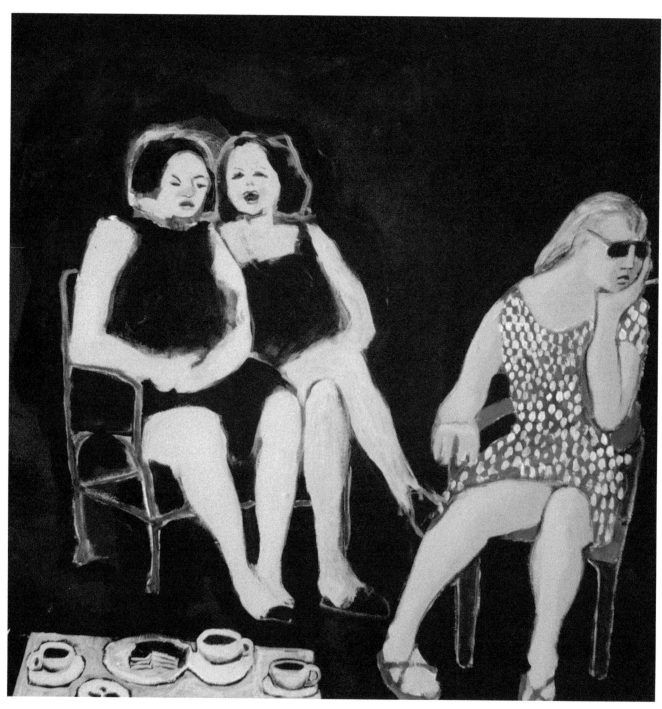

Behind Her Back   *Acrylic   48"x 48"*   1978

44

room she could hear their muffled laughter trapped like disoriented pigeons behind the drapes and under the chairs, and even in the carpeting.

She was also positive that strangers in stores and restaurants were talking about her, about how her dress was dirty and how she had to wear sunglasses at night because her eyes were puffy, and why wasn't she wearing any shoes or underwear, and she hated the fact that they could look into her brain and see her thoughts crawling around like bugs.

On December 8, while spending the evening alone with a bottle of vodka, she picked up a hammer and launched an attack on her old enemy, the furniture. She beat to death two Chippendale chairs, bludgeoned beyond recognition a beautiful Knoll couch, and severely damaged several exquisite cloisonné antique clocks. Next morning their divorce was decided on, and their dog Charlemagne celebrated by eating a large plate of Nova Scotia salmon Martha had left lying on the floor where she had dropped it.

Now Martha lives alone in Mandeville Canyon with her own horse and her own house. She is an expert rider and a practicing landscape architect thanks to her husband's clients. Forced to communicate more honestly during the divorce, Martha amazed herself by ending up good friends with her ex-husband who still supports her and insists on talking to her every day. Their big joke together is that if they get along this well at fifty they think they'll marry each other again.

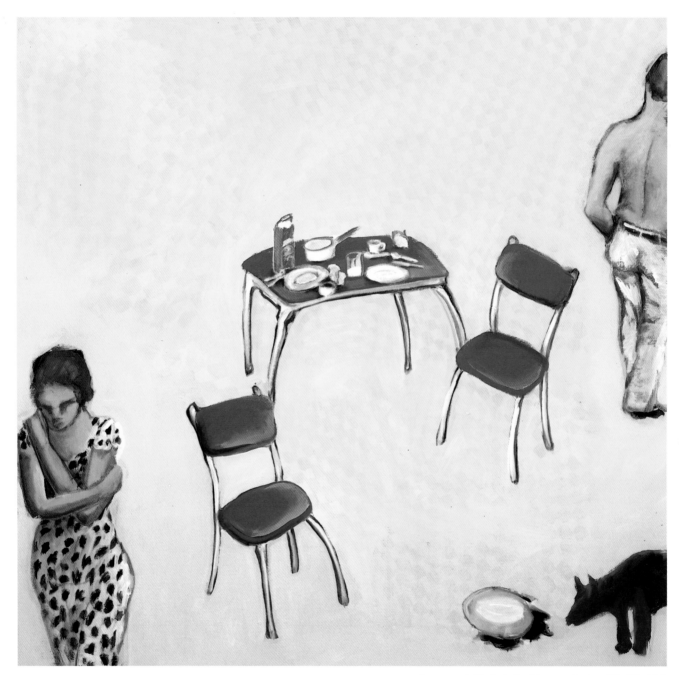

Opportunity In The Right Hand Corner    *Acrylic    48"x 48"    1979*

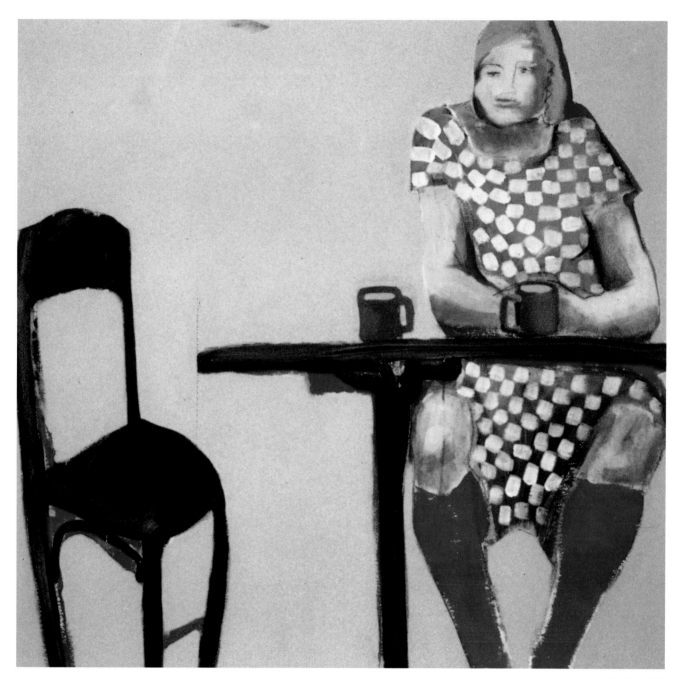

Martha  *Acrylic*  48"x 48"  1977

Slow Dance    *Oil*    *72"x 72"*    1985

# 3

# DANCING

PROMS, TEA DANCES, and country club formals were the nightmares
of Adele's life. Adele dreaded these events, even though she got all dressed up
every Monday after school and went to Grace Church where Miss Hepburn
taught ballroom dancing, an accomplishment her mother hoped would improve
her manners and her balance. All Adele could see it improving, however, was
her frustration over boys and her depression at being an unmanageable giant in a
room full of twirling dolls, all beautifully dressed and in perfect step. The only
way she could impress anyone was to show them the long hat pin that she
carried in the index finger of her white glove, but this only further reduced her to
the category of left over girls who had to dance with each other. Forced to take

*Blue Prom Trees*
the man's role because of her height, Adele spent the
hour pushing fat ugly girls around the sides of the room
to the strains of Strauss, or Stress, as she had renamed

him. She complained bitterly to her mother that Miss Hepburn's ballroom-
busting class was teaching her to be a lesbian, pointing out that this was certainly
something she would later regret. Adele demanded that at the very least she
should let her wear nylons like some of the older girls who were already dating.

The next time Adele pushed little Julie Temple down the back side of
the ballroom in a particularly ponderous tango she was wearing a bizarre
suspension motif about her groin area that made her feel a lot more like an idiot
marionette than a graceful woman.

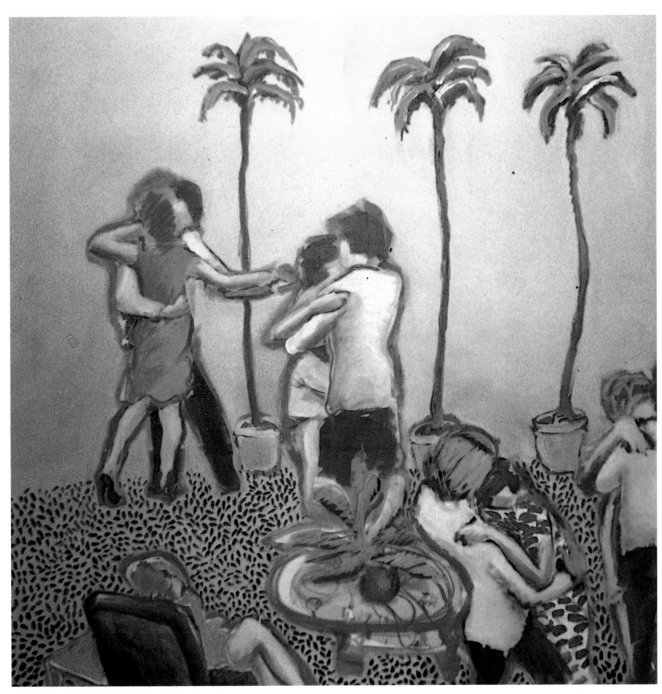

Blue Prom Trees   *Acrylic*   48"x 48"   1980

IT WAS JUNIOR HIGH where Adele discovered the true function of dancing. It was the next best thing to sex, and since she wasn't having sex at that age, dancing was the best thing in the world. The agenda of the Grace Church Youth Club, where Adele first came into contact with boys, involved one hour of murderous dodge ball fought out in the church basement followed by slow dancing to The Platters in total darkness. What sex-crazed Episcopalian chaperon thought up this schedule isn't known, but she would like

## *Smoke Gets In Your Eyes*

to thank him for some of the most erotic moments of her youth, when exhausted and still sweaty she danced with Bobby Lane, the boy who only moments before she had tried in vain to cream with a large rubber ball, and who she secretly swore in the depths of the basement she would someday kill.

When Bobby asked Adele to dance she couldn't believe it, and made a face to all her girlfriends. She was sure he hated her as much as she hated him, but when he held her close and her quivering stomach threw itself up against her rib cage she realized to her embarrassment that she was helplessly in love.

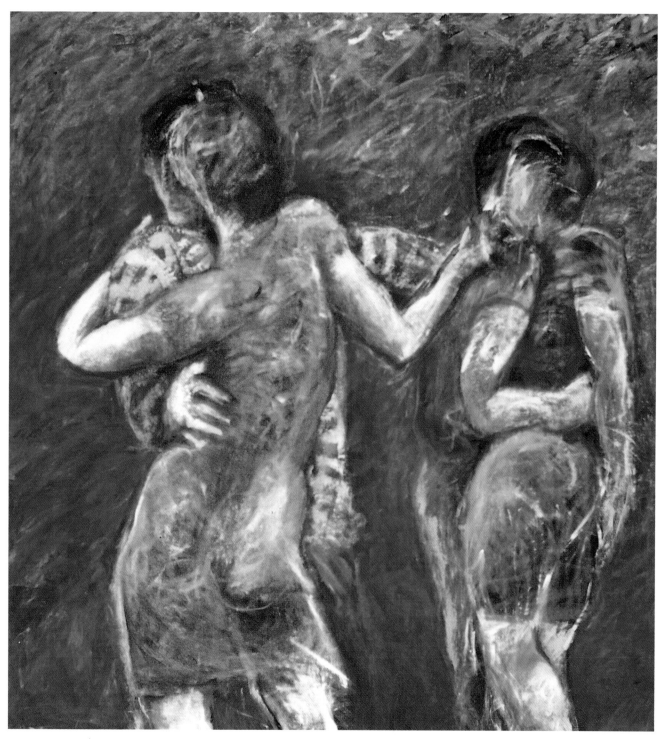

Dancing In Blue    *Oil*    60"x 66"    1985

PROUD OF HER DANCING lessons, Adele's mother would often insist that she dance with her stepfather before the bands of the various hotels she dragged them to on vacations. Adele never understood this activity and always protested against it. She didn't want to dance in the arms of the man her mother found sexually attractive. She knew men had written about the pleasure of holding a young girl through the fox trot, but she didn't think very many young girls had had the chance to expound on being held by an old man through the same trotting fox. Just as he felt her blood rushing, Adele could feel her stepfather's blood thinning — her life was spinning before her, while his was

## *Eaglesmaer Hotel Waltz*

tumbling behind him, and she realized that this adult on whom she was still dependent for school and books and clothes was not going to last forever, and she was dancing with death — somewhere amid the warm smiles and music a cold skull is grinning at her.

Adele wondered about her mother sitting there smiling with that look in her eyes. Was she amused at the irony of her husband clutching his past youth and her daughter embracing her inevitable future? Or did she just think what a pair of fools, their timing is so bad.

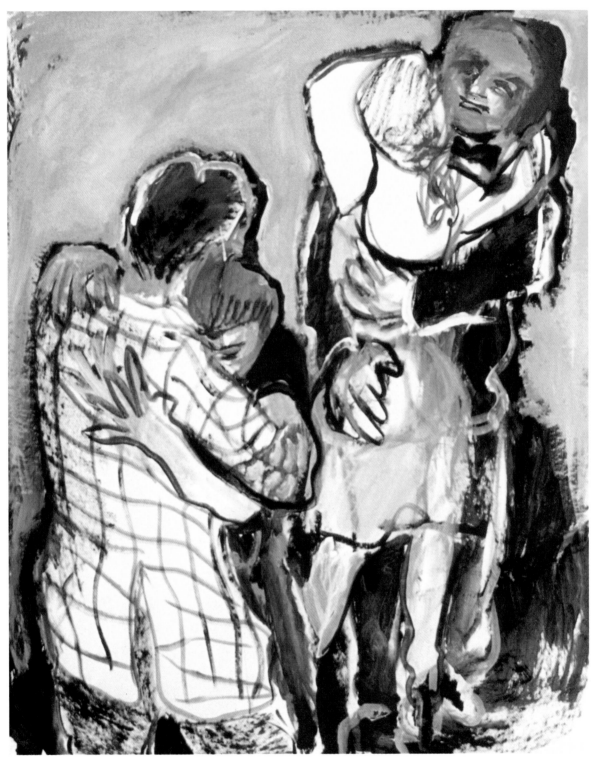

Hotel Waltz    *Acrylic*    *36"x 48"*    1982

YOU COULD ASK HER HUSBAND or her best girlfriend, Nora was a nice girl, nice in bed and everywhere else — except on the dance floor. On the dance floor she turned into another person, a wild person. Thrusting her pelvis forward rhythmically, legs apart with her hands on her tits, her mouth making strange sucking noises. Throwing her ass in the air, she would begin a hungry moaning sound that suggested she was about to regress to the primeval rhythm that propelled her before God put his order on earth and mankind. Usually people just averted their eyes and waited for the music to stop. They knew that Nora was not really like this.

It wasn't that she turned into a flirt; one couldn't call it flirting — the gyrations and gestures that Nora made were frightening. Motions called up out of a prehistoric past by some genetic coding flaw; they reminded one of strange rituals in a bacchanal or the gestures of the town mystic in his trance. When she was young it was attractive in a freakish way, but that was in the sixties when everyone was wild. Now her children ran from the room with their hands over their mouths. Her husband had long ago refused to dance with her and so she was quite accustomed to dancing alone. Once when she was dancing close to the stage the band stopped playing.

## Moroccan Vacation

No one had the heart to tell Nora that she shouldn't dance that way. Instead her family conspired to keep her away from music, and that seemed to work until she and her husband took a trip to Morocco on their twenty-fifth anniversary. One afternoon at the bazaar Nora and her husband got separated and when he found her it was too late. She was surrounded by a crowd of desert nomads madly playing instruments and singing while Nora twisted in the sand pulling off her clothing piece by piece. When her husband tried to drag her away the crowd cried out and threw stones at him. One of them hit him in the head and when he woke up Nora and the nomads were gone. No one ever saw Nora again.

Dancing Ghost   *Oil*   48"x 60"   1988

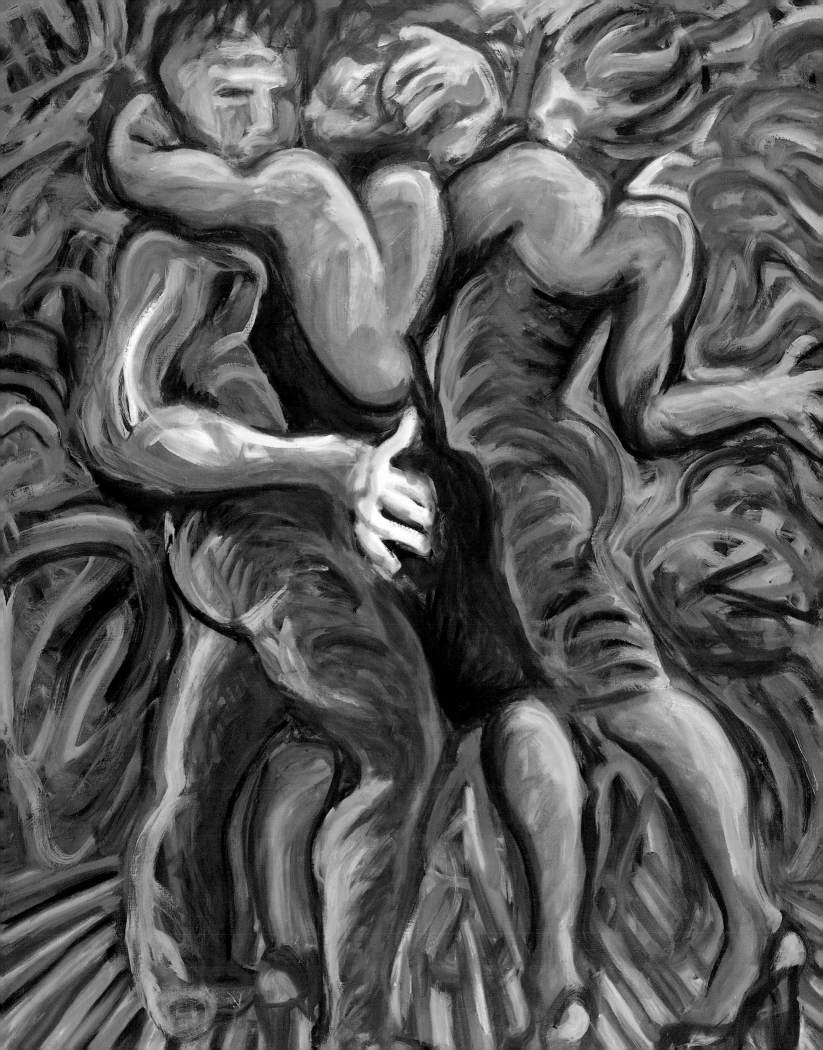

SHE SAYS THERE IS NOTHING lonelier than dancing on a stage before a river of vacant eyes. Lots of girls jumped over this river, jumped on stage when they were too young to be uptight, but Angie didn't make it to the other side. She got stuck in the middle, caught by her own reflection in all those empty eyes. As she got more professional they asked her to wear fewer clothes,

*Promised Land* as she got older they asked her to work cheaper clubs, and as her gyrations became more mechanical they started to snicker. She looks like a desperate machine, one guy laughs. No, she looks like a tired hooker another guy mutters, and you're shocked—that's your old girlfriend everyone is watching. Her arms make stupid swimming motions as your boat pulls quickly away.

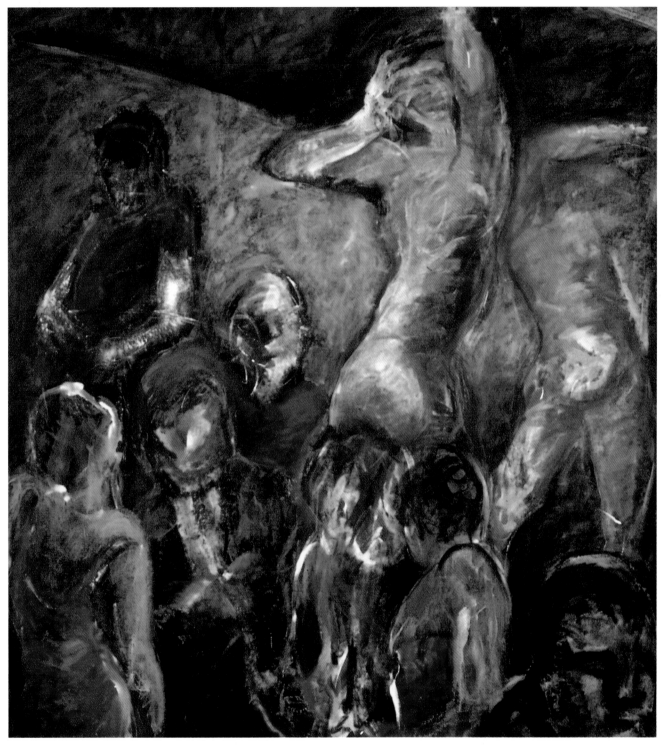

In The Promised Land    *Oil*    72"x 84"    1985

SHOES WAS HIS NICKNAME. We all called him that. He was an
incredible ballet dancer — of course we were all incredible somethings back
then. Tina was an incredible shop-lifter, and Barney was an incredible woman
when he wasn't driving sixteen-wheelers cross-country. We were a bizarre
group, but we had one thing in common. We all got our speed from the same
dealer, Larry the Lizard. In the fairy tale, *The Red Shoes*, the devil makes the
shoes, but in this story the cobbler is a lizard.

Shoes was always too high to join a ballet company but nonetheless he
was fiercely devoted to his art. In restaurants he would jump up from the table
and dance instead of eating, on street corners tossing glitter everywhere he
would dance instead of walking, and at the Lizard's he would dance for his
dope in just a loincloth for days without stopping. He couldn't stop. At first it
was nice knowing that someone was on Larry's roof doing *Swan Lake*; we even

## Dancing In The Grass

brought lights out for him at night. Then
it wasn't so nice and we brought the lights
back in hoping it would rain. As the night
grew thin we struggled to stop him, but when you held him down on the bed
he danced horizontally. Disgusted, we threw him outside and he danced away.

I last saw Shoes in Central Park dancing with some homeless people,
sort of waltzing in the grass. He was ragged, burned out, and I realized he
hadn't been able to stop dancing. He whirled right past, not even recognizing
me. A week later I was told that he was dead, the first of our group to
defenestrate himself. I guess when Death finally came, Shoes didn't know
what else to do, so he asked him to dance, right out the twelfth story window.
As for me, I avoid Central Park because I like thinking that Shoes is still there,
dancing in the grass.

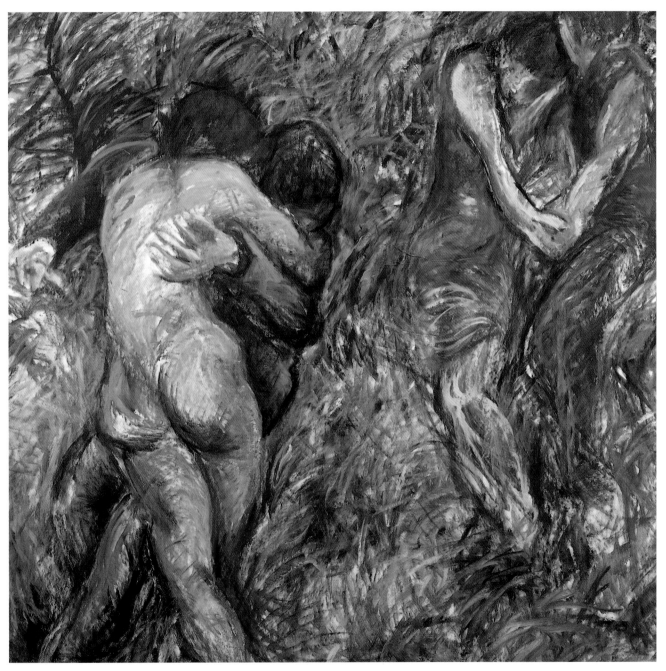

Dancing In The Grass    *Oil*   73"x 70"   1985

"I'VE BEEN COMING here for years and I have never had a problem with the clientele, but when a woman cannot sit alone without being bothered,

## *Blue and Brittle*

pestered, and pawed to death...Why have you hired that awful band? It attracts unsavory people. The music is too loud. I am too old to be dancing and have men trying to kiss me in a public bar. The people here used to have manners and class and...and..."

"Ah Mrs. Hamenski, I did not realize the band was so offensive, and by the way, a gentleman has just left a box of orchids at the desk for you."

"Orchids?"

"Yes, white Cattleyas. Everyone has been admiring them."

"Don't let them touch them, they're fragile. Is there a card?"

"Yes. 'Dinner at eight,' signed Mr. Knight. He's a guest in the hotel here, from São Paolo, a very well connected family. Did he meet you in the bar last night?"

"Yes."

"Oh. What should I do? Throw the orchids out?"

"No. You can send them up. That will be all for now, thank you."

"Very well, Mrs. Hamenski, good-bye...

Hey Rico, you're working tonight, number thirty-three. She's set up for dinner at eight, and don't maul her to death, she's skittish."

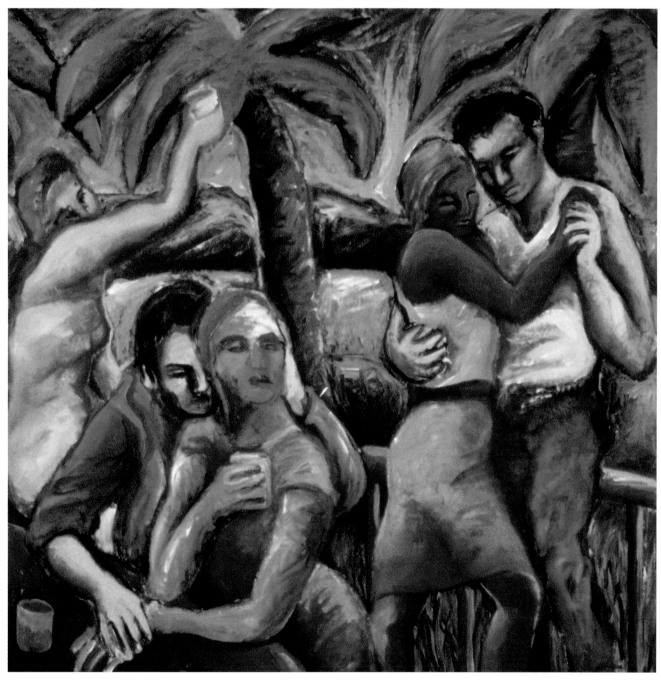

Blue And Brittle   *Acrylic   60"x 60"   1984*

AT NIGHT WE GATHERED together in a little outpost bar on the perimeter. The perimeter of what, you ask? Yeah, well, it's been so long I can't remember. It was the edge of everything: good bad, living dying, night day; like the first boundary you learned as a child, one side is home, the other is danger. Our duty was to guard it, but like I said, it had been so long we'd forgotten which side was which. Not that it mattered, we had plenty of supplies, and way out here we were isolated from the wars and insulated from the plagues, but still it was lonely. So we partied heavily in this bar at night, and strange travelers would come around to see what the noise was about. That's when the trouble began.

This one stranger used to drop in every so often and he always wanted to dance. He was beautiful in an androgynous sort of way so that men or women didn't mind dancing with him. With pale skin and sad smile he would sway

*Black Dance*

to the music till you thought his heart would break and you couldn't refuse him if he asked you to dance. Whoever danced with him would follow him after he left and never be heard of again. If we tried to stop them from leaving they would fly into a rage or sicken with pain until we let them go.

We were guards, we only did as we were trained to do. When we killed the stranger it was listed as a Code Three, a threat to security. Now the cities have all turned to rust and the hillsides beyond them to dust, and we remain without hope as the century slides by. Oh, we are the heroes that conquered death all right, but if you ask me it was a big mistake, that stranger was our only escape.

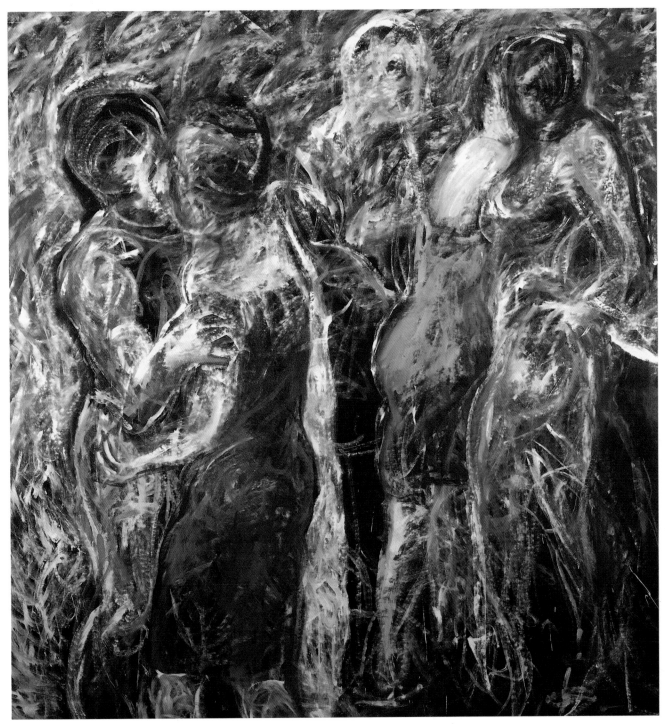

Black Dance   *Oil   82"x 84"*   1985

Take It Off   *Oil*   *36"x 48"*   1987

# 4

## KITTY
## LITTER

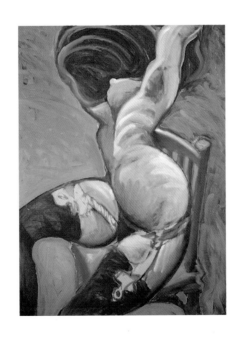

WHEN KITTY LEFT HOME she was twelve and she never remembered anything about it ever again, and when a man picked her up and drove her all the way to L.A. for certain favors she grimly forgot him as quickly as she could too. Already she could walk like a hooker, she knew about AIDS, and where to cop. She had a great body, there was no denying that, but she had an ugly face and her voice was truly obnoxious, like a peacock's. This didn't stop Kitty, however — nothing stopped her. Fighting was the same as breathing to Kitty.

At first the gang she wanted to belong to wouldn't have anything to do with her. They were a ratty vicious little bunch of girls from about thirteen to eighteen that called themselves The Ladies of Selma. Not that there was anything ladylike about Selma Street. It lay below Hollywood Boulevard like the ugly sister — ignored, unkempt and given to outbursts of ill-tempered behavior — but to the gang Selma was glamorous; full of drugs, danger, prostitution, and enough violence to satisfy the anger boiling in their young hearts. Ignoring the curfew the gang covered every inch of Selma with their makeshift

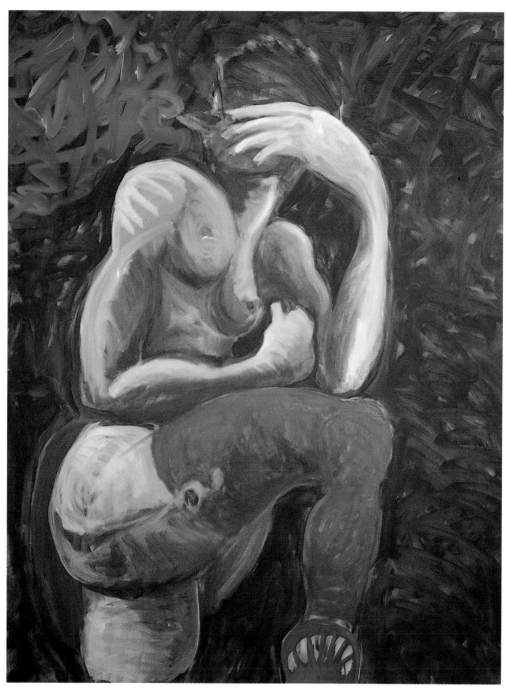

Kitty Litter   *Oil*   36"x 48"   1987

weapons and their stolen costumes, followed by Kitty yelling curses from a distance in her blisteringly foul voice. Nobody knew as many curse words as Kitty. I think it was just to shut her up that they finally let her join them. Some of the girls said that there was animal somewhere in her background, that one of her relatives had mated with something more vicious than a human being. It was the only way they could account for her wild streak. The more serious members of the gang put her talents to use in cannibalizing cars, which was their main source of income, and in no time Kitty became a gang leader. She was also wanted by the law for theft, property damage and assault, but she was too young and too much trouble to catch; besides after the gang wars started, the law stopped patrolling Hollywood at night.

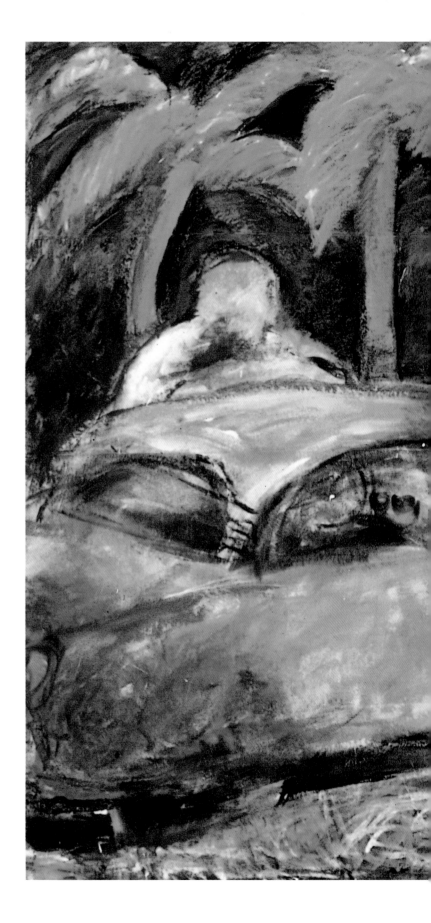

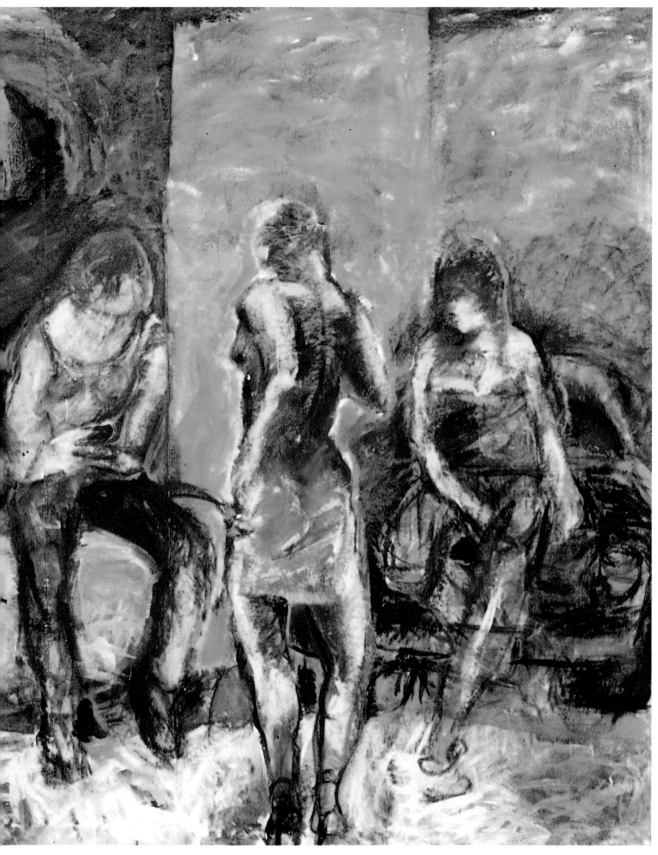

L.A. Nights   *Acrylic   144"x 108"*   1983

71

On July 4 when the missing ozone layer had turned Selma into a cement rotisserie, an all-male surfer gang invited them out to Venice Beach — not that anybody could go swimming; the ocean was so full of poison it glowed like a luminous lung that had been lifted out of the chest cavity of the sky and now lay on the sand breathing its last. They partied desperately at the feet of this eviscerated giant, drinking and vomiting in each others arms. The leader of the surf gang said that the only way he would fuck Kitty was with a bag over her head, whereupon Kitty dumped the beer out of a bag and said, "Let's go, dick head." His name was Bobby and rolling her over in the sand he uncovered what had to be the most incredible ass any of them had ever seen. When it was cool enough to go home, Kitty tried to get in Bobby's car, but he punched her in the mouth yelling that just 'cause he fucked her it didn't mean he wanted her, but when she took off all her clothes in the parking lot without saying a word, covering her face with her hair, he picked up her clothes one by one and told her to get in the car. That was the last The Ladies of Selma ever saw of Kitty, until the old couple showed up, walking up and down

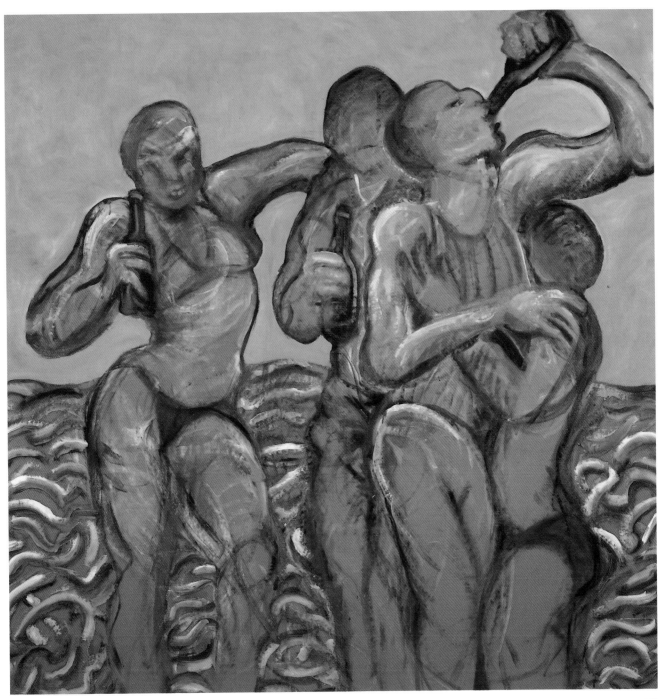

Beach Party  *Oil*  62"x 63"  1987

Head Turner    *Acrylic    56"x 72"    1982*

Selma asking their endless questions and showing the photo of Catherine.

Bobbie Brat told them that from that day at the beach on, it was a battleground between them, him pushing her away and her screaming for more of him. There never was anyone else for Kitty and they fought until they started chasing the dragon, then things became very calm and Kitty got what she wanted. Bobby had to stay with her because when the stuff ran out she could always get more just by lifting her dress on the Boulevard. You see, heroin broke up the gang, just dropped it in the street like a china white plate, and now everyone lays scattered about in doorways and bathrooms like bits and pieces of crockery. Some people say the government's pushing it, but we don't give a shit, we just wanna stay high.

Dede Troit said Kitty was the only one that got stronger on the stuff, so strong she began to scare Bobby and he tried to tear her down, tried to break her so he could get away, get himself together. He told her he needed a lot of money to pay off a dope deal and he had arranged for her to pull train out in the oil fields on La Brea. Word

Hit Her   *Acrylic   48"x 60"   1982*

Let's Make Love   *Acrylic   48"x 60"   1982*

went out and guys drove in from everywhere. Kitty just lay down and took on a hundred guys one by one until Bobby had over a thousand in his hand.  Afterwards Kitty said she was hungry and they went to a burger place where he watched her eat fifty hamburgers.

Critter said that that was nothing — that they had made over two thousand dollars by

Car Hook   *Acrylic*   *60"x 48"*   *1982*

Boy Dares Cars To Run Over His Girlfriend   *Acrylic*   *57"x 65"*   *1983*

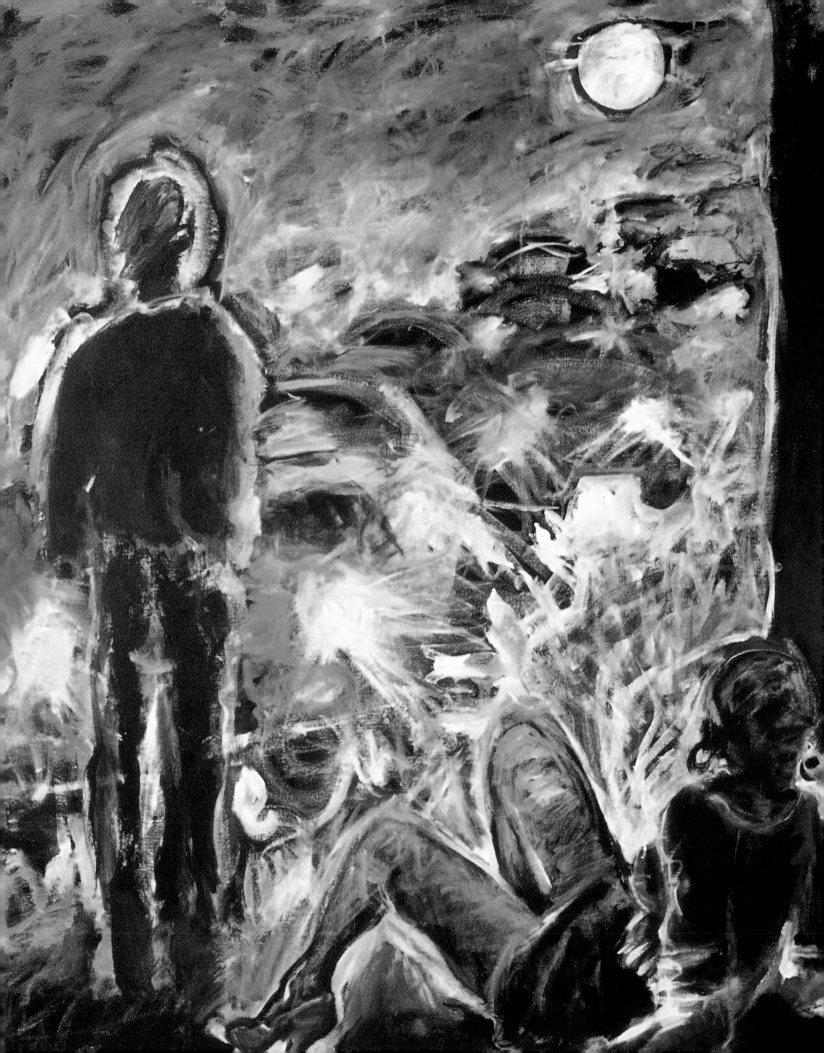

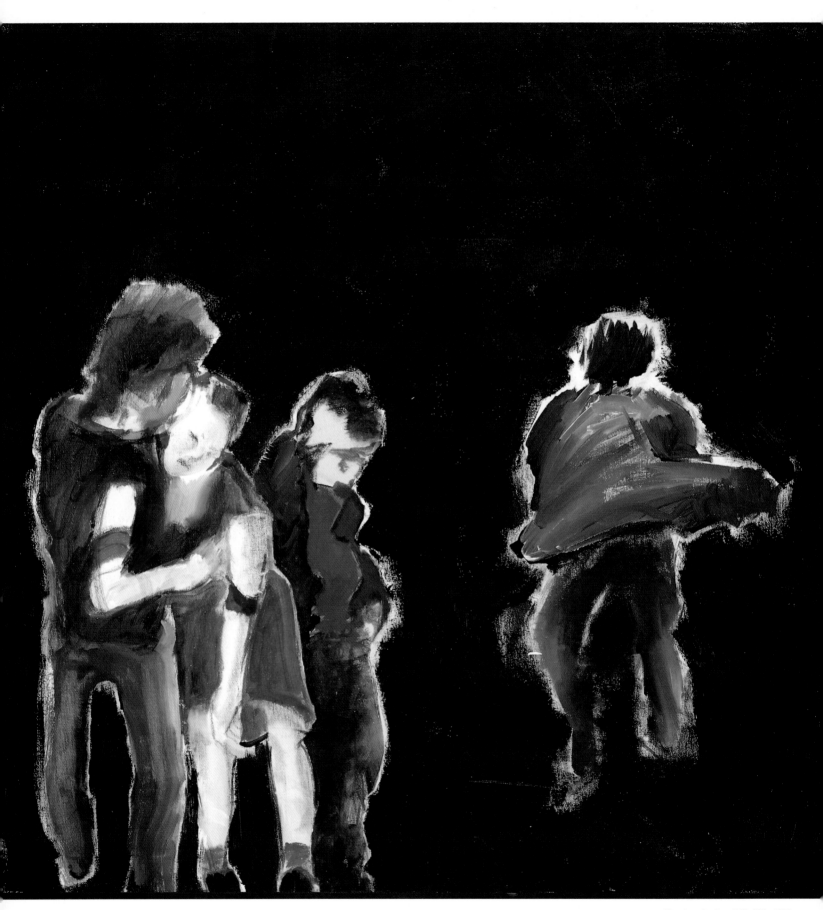

Heroin   Acrylic   36"x 36"   1981

putting on a show where she had sex with a dog.
Two thousand dollars and it only took her half an
hour — now *that* was easy money.  They started
doing it regularly, started working the circuit; from
the empty warehouses outside L.A. where they
shared the bill with a couple of amazing cock
fights, to the gated mansions of Beverly Hills
where real freaks did things that no one thought
possible.  And through it all Kitty just got stronger.

Yeah, Sharin Needles piped in, they became
a team.  Bobby was the manager and Kitty the
performer.  Bobby got a lot of expensive tattoos

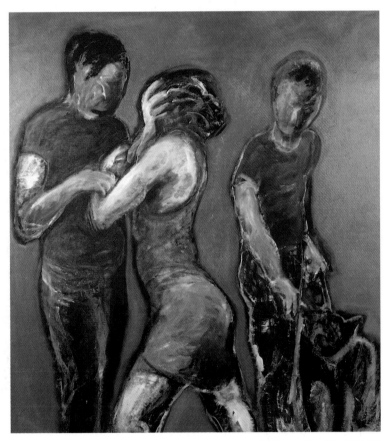

Dog Date   *Oil   64"x 69"*   1984

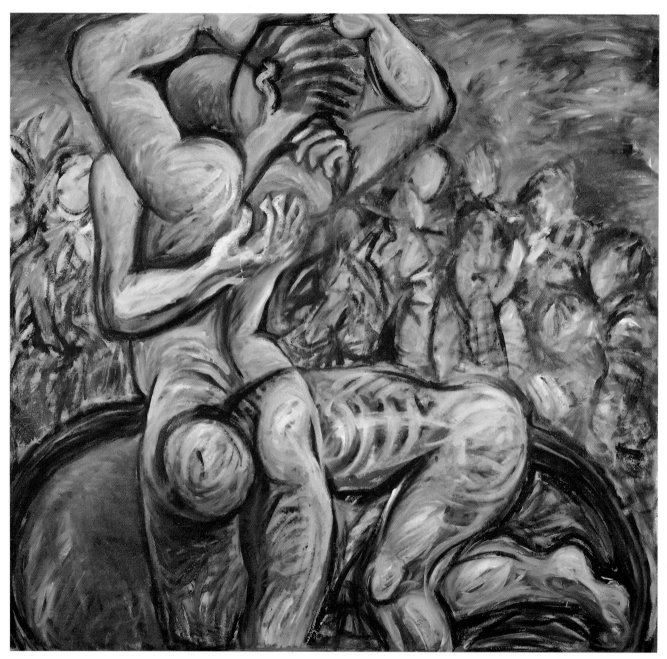

Meat Eater Circus   *Oil*   72"x 72"   1989

and Kitty, with the help of plastic surgery, became more and more beautiful, until one night a man with saliva and cum smeared all over his very expensive trousers and even on the tips of his velvet slippers, asked Kitty if she would join this underground sex circus, and now they tour Europe all the time as art stars, and famous people come to watch them.

That's bullshit, said Miss Karriage. Kitty made three porno movies and Bobby kept the distribution rights to them all. She was the best, her movies were sold in plain brown wrappers throughout the world 'cause the world can only have sex by celluloid because of the increasing disease. They bought a home in Las Vegas and another in Brentwood, and one in Palm Springs too. They became health addicts, and upstanding members of the community, and she and Bobby finally tied the knot so that he was not only her manager, bodyguard and lover, but her husband also.

But Terry Cloth just laughed. Bobby could never stand her, she said, and when she didn't leave him alone he had her killed and cut in half, and the top half he threw away and the bottom

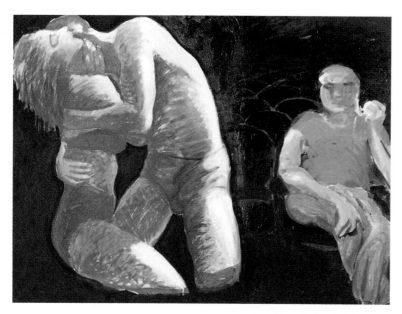

Porno Man    Acrylic    48"x 36"    1980

half he had bronzed and it's in his house in the San
Fernando Valley right now with an ashtray on it.

I told them I met her in the back seat of a white
Cadillac. She said, "Hi, I'm Kitty Litter, a box you can
dump in." Her mouth was maybe twelve with the
lipstick of a thirty-five year old. Her skin was white
as porcelain except where someone had written
"Bobby" on her neck in ball-point pen. I never saw
her again but I never forgot her. She couldn't have
weighed ninety pounds but the impending abuse that
hung over her was an oncoming avalanche.

Fur wouldn't even talk to the old couple. It
certainly took you a long time to figure out she was
missing, was all she had to say.

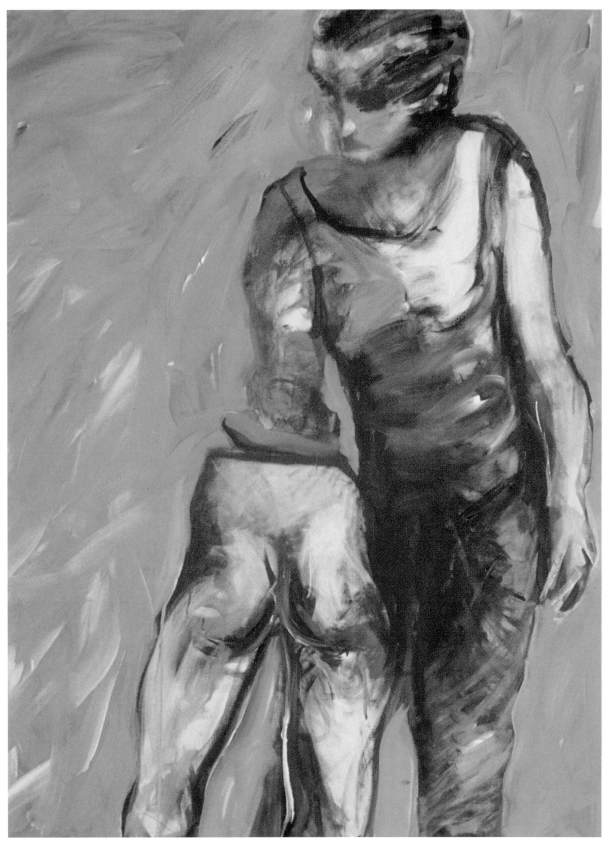

Cut Her In Half And Use Her As An Ashtray   *Acrylic*   *36"x 48"*   1983

Wake Up And Blow Me   *Acrylic*   *60"x 60"*   1983

# 5

## R O M A N C E

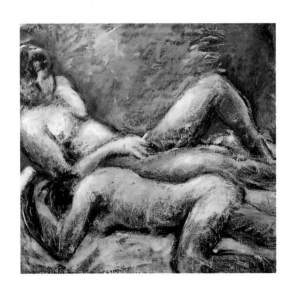

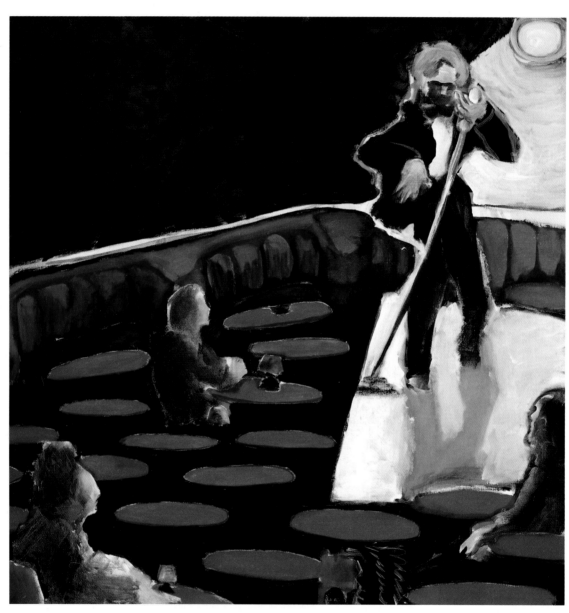

Working The Room   *Acrylic*   *36"x 36"*   1981

MARGARET LOOKED around the room at her competition. She was almost the prettiest girl there and certainly the prettiest redhead. Some ugly girls were there too; they must either be really talented or have some kind of gimmick. That worried Margaret. Maybe they were smarter or they took off

*Audition*     their clothes or were wildly funny. How could she compete against that? After all, this was just a cigarette commercial, not Shakespeare. Still, she worried, which gave her a frown line even though she was only twenty-three. She had to think of some angle for herself, something she could do. Too late. The casting lady stuck her head out. "Margaret," she smiled, "come on in."

Inside about twenty people were seated against the wall and in front of them was a long white rug. "Margaret, we want you to pretend that this rug is a swimming pool. Now, we want you to jump in, swim the entire length of the

pool, then hop out, fling your hair back and light up a cigarette. O.K.?"

"Sure," said Margaret, taking her place at the foot of the rug. That's when it hit her; if Icarus could fly, she could swim. Slipping off her clothes she dove onto the rug. Nobody moved a muscle as she swam through the awkward silence of the room to the end of the rug where flinging back her hair she posed and pretended to have a cigarette. Still no one said a word, it was silent until she got up and put her dress back on. Then the casting lady smiled and said, "Thank you, Margaret. That was wonderful, thank you."

Later that night when Margaret's boyfriend saw the rug burn on her stomach he hit her because he thought she had fucked someone else. When she told him what had really happened he left her.

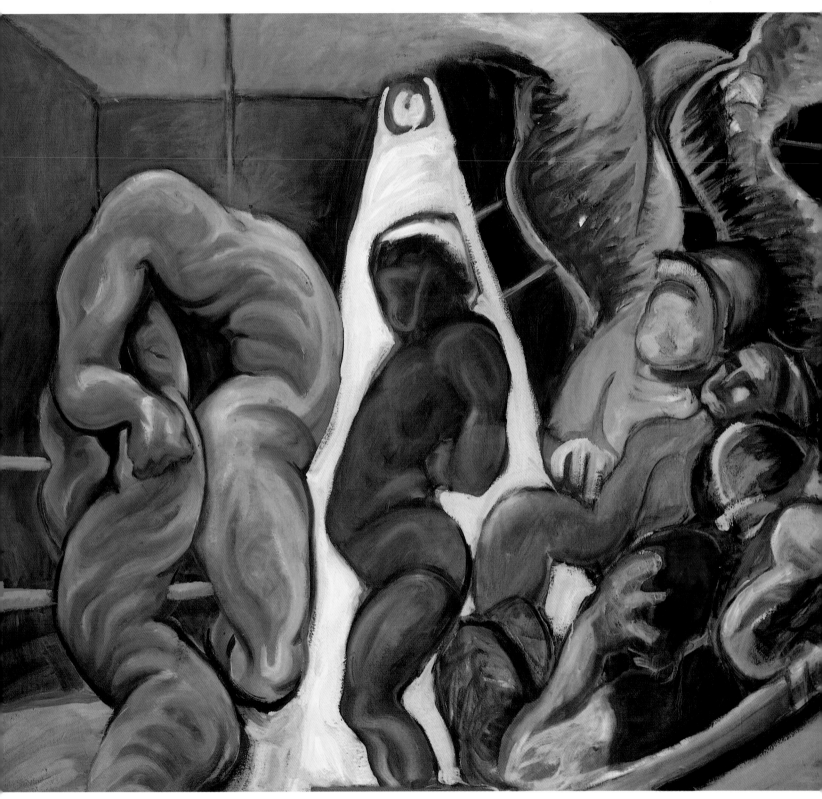

Audition   *Oil*   *58"x 51"*   1990

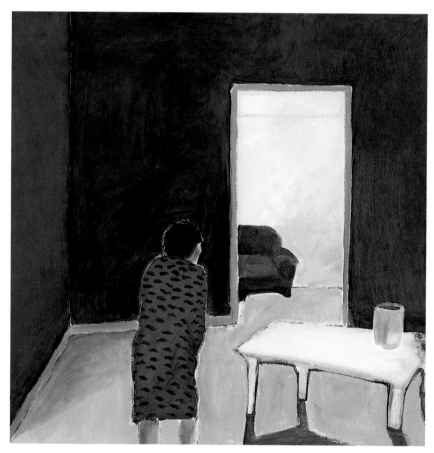

Rm. 419   Acrylic   36"x 36"   1980

DATING IN L.A. had always been a problem, so when Gloria decided to advertise in the personals her girlfriends didn't think she was being desperate; on the contrary, they admired her balls. After a few lame dates that really upset her one of her girlfriends suggested phone sex and gave her a number. Gloria

## Love Is Blind

connected with someone right away and pretty soon they had exchanged numbers and were having their own private phone affair. Within a week or two of nonstop sex calls she told her girlfriends that they thought they were in love, and that they were going to meet. He had suggested they meet in a hotel room, blindfolded, where they would make love before seeing each other's face.

Gloria arrived first at the Beverly Hills Hotel room. By the bed was a bouquet of fragrant flowers and a chilled bottle of champagne. She had a small drink while she removed her clothes and put on the blindfold. Stretching out on the bed white as an iceberg she felt like a young seal in the Alaska sunshine. If

she lay very still she could smell the flowers across the snowy sheets. Finally there was a knock at the door and a familiar voice said, "Gloria it's me, I'm putting on my blindfold and coming in." They laughed as he fumbled his way out of his clothes and bumped into the chair, but when their skin touched the room seemed to break off from the hotel and float out into the midnight sea.

When Gloria told her girlfriends what had happened they couldn't believe that she hadn't looked at his face. Gloria went to the hotel again and again but stubbornly refused to take off her blindfold. Her girlfriends' voices flew around her ears like mosquitoes stinging her with uncertainty, until finally Gloria relented and one sunny afternoon removed the scarf from her eyes. At first there was a halo of light and then two sad eyes stared at her from the ugliest face imaginable, he was old and his skin was plagued with bumps and scars. As he repeated "I love you, I love you," her only thought was to get out of the room as quickly as possible. She was dressed and in the lobby in seconds. She couldn't be seen having lunch with him, much less an affair.

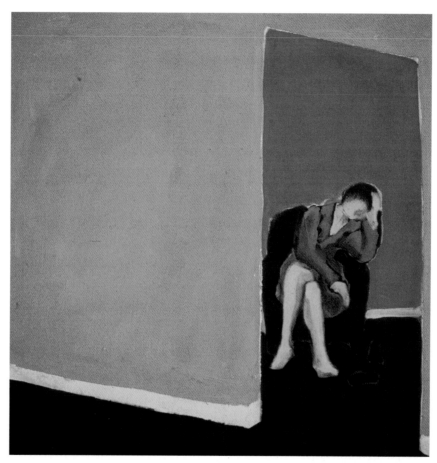

Rm. 218    Acrylic    36"x 36"    1980

ANN HATED TRAVELING. It came from being sent away as a child. It wasn't until her mother had remarried that she was allowed to come home from boarding school, and after that she didn't want to go anywhere ever again; if her mother even mentioned summer camp she would tie herself to the leg of the dining room table with the telephone cord and cry inconsolably. When her new parents started vacationing a lot Ann figured she needed a backup just in case they forgot to return, so she made best friends with a rather unpopular girl in her class named June. They became inseparable. In high school they double-dated and in college they had their first romances at the

## Best Friend

same time. June actually turned out to be very pretty, going from unpopular to most popular in junior year, but Ann wasn't jealous, their friendship was iron-clad, and when June started falling in love with Tony she still wasn't upset. She just considered June, Tony and herself a threesome. When they partied together sometimes Ann would have a date and sometimes not.

Even when June married Tony things didn't change. They vacationed together and Ann moved into a house only three blocks away from theirs. So you can imagine how Ann felt when Tony called to say June and he were moving to Ohio. At great expense Ann managed to move to Ohio also, but before she had settled in Tony called again to say they were on their way to Oregon and please not to follow or even say good-bye. Ann couldn't believe it. Winding the telephone cord around her wrist she began crying into the phone. "You can't treat me this way. I may be down to my last penny but I'll take a bus to Oregon. I'll find you if it's the last thing I do, and when I do we will never, never be separated again. Mark my words, never, never again."

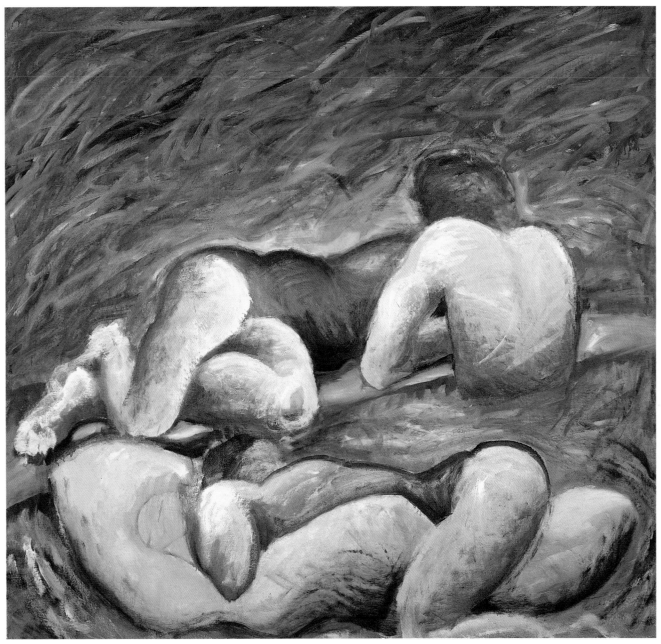

Jealousy On A Raft    *Oil*    56"x 56"    1987

HE SAID the Kennedys did it with Marilyn Monroe. That was his biggest argument, that and that kings and queens used to do it all the time, although he wasn't sure which kings or queens. He had been on about this all night, and Doris was beginning to lose track of what she really felt. At first she thought the idea of fucking his best friend was an insult, but now she just wanted to make him like her again, and it didn't seem like such a hard thing to do. She knew it

*Doris*   wouldn't take long because the girl who used to go with his friend was always complaining that he did it like a rabbit. When he started getting mad at her and calling her a wimp and saying how she didn't care what he wanted, how it would make him look bad if she didn't do like he said, and how it was obvious that she really didn't love him, she knew she was going to do it — she just wanted things to be all right again.

It wasn't until after she had let his best friend come all over her that she knew she had lost him forever, that he would never like her again, nobody would. She cleaned herself up and acted like she had had a great time, but things were different now. Now there was an edge to her voice that didn't used to be there, and there was someone else who didn't like her, someone far more important than all the others, someone who lived inside her skin.

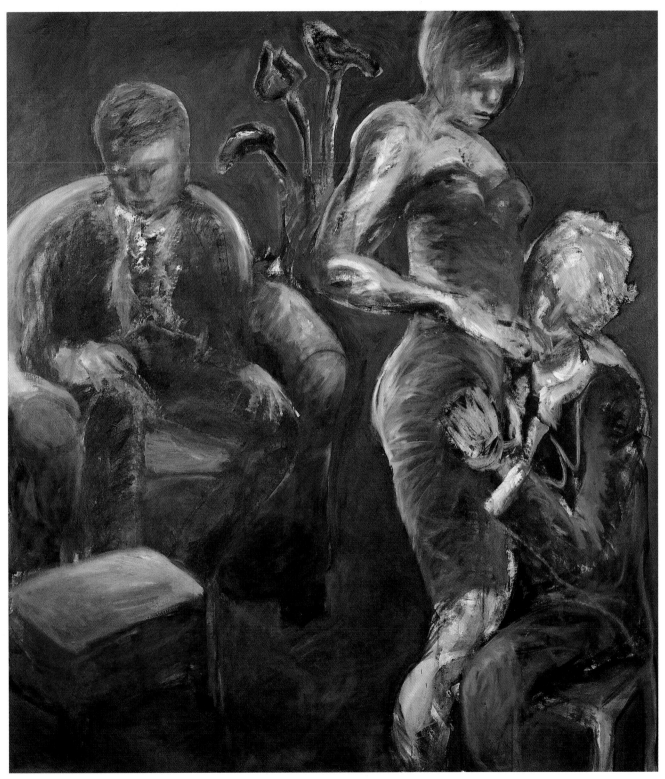

Three Blind Mice   *Oil    58"x 64"*   1986

AT FIRST Ben thought Jack was kidding. Then when he realized he was serious he couldn't help thinking maybe the city had made Jack queer, but no — he had known him all his life and nobody could be more heterosexual than Jack. Jack had been the first one of their group to put it to little Anne Wrigley, the junk man's daughter, out on Hollow Crest Road. Jack could get any girl he wanted and he had, at one time or other wanted every girl in Mill Valley and some of the women too. Jack was a legend at Greymount High and Ben had been proud to be his best friend back then. Well, sidekick was more like it. Ben knew he was boring and if it hadn't been for Jack nobody would have bothered to talk to him, but Jack had always insisted that he be in on everything, just like they were brothers.

Now Jack was back from New York City for the summer. He had to rest he told Ben, and rest meant sitting all day in the dark insides of the Wagon Wheel cocktail lounge on Highway 7, drinking bourbon and beer and going over his sexual exploits with that incredibly charming grin he had. Ben could listen for hours. He also liked looking at the waitress's ass. I mean, she would never give a little guy like him the time of day, but with Jack around she was kind of showing off and Ben sure did like to watch her. That's when Jack started in on his scheme that they should both fuck her. Ben knew she didn't like him so he shyly told Jack to go ahead, but Jack said no, that wasn't the point, he could talk a woman into anything, so why shouldn't both of them have her? It seemed kind of mean but Ben finally agreed. He had never seen Jack so happy.

It was the most difficult performance that Ben had ever had to give. When the waitress started complaining in a shrill voice that talking was the only thing Jack could do any more, Ben was so embarrassed for his friend that he put his arms around her to shut her up. Then coached by Jack's grinning voice from the other side of the bed he made her purr in satisfaction as warm tears of shame ran down his face for his friend, who pleaded in his ear, "Do it for me Benny, come on, fuck her for me, that's it, yeah."

*Seconds*

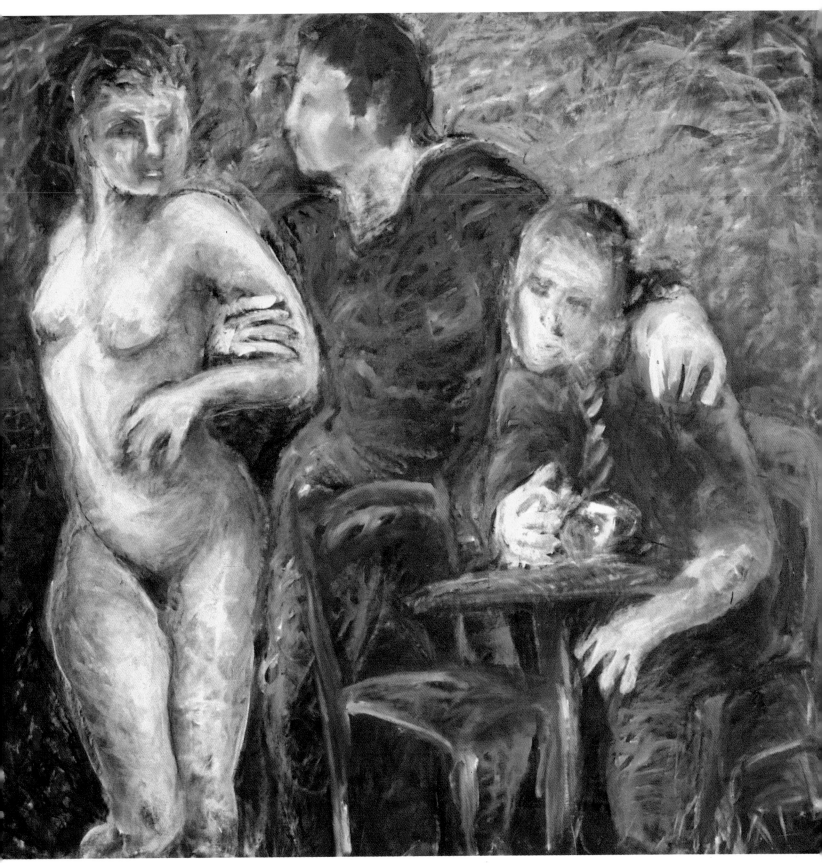

The Introduction   *Oil   83"x 80"*   1986

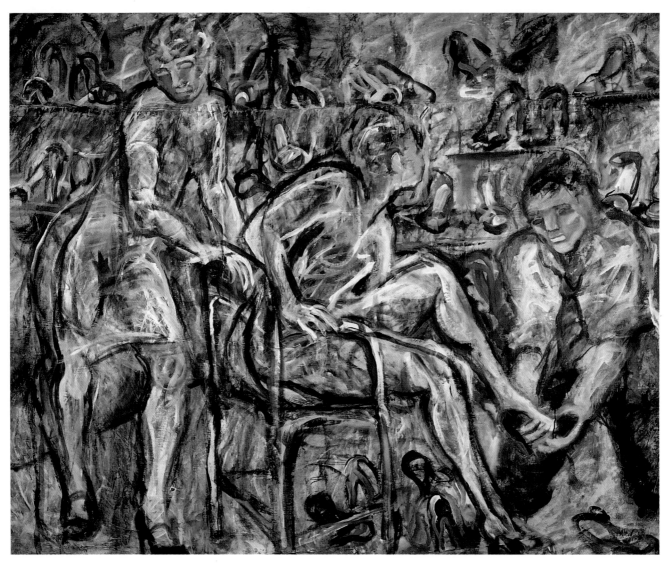

Shoe Store I   *Acrylic*   *84"x 72"*   1983

SUSAN DID TWO THINGS in life — she worked in a law firm and she went to A.A. meetings. She was not particularly attractive, and her social life was dead. At thirty-nine it was quite apparent that if anybody was going to be nice to her she had to be the one to do it, which is why she suddenly decided to buy the shoes she had been staring at for a month in the store next to the bus stop. The store was owned by immigrants all of whom could barely speak English and none of whom she trusted or understood. The man who insisted on waiting on her must have brought her eleven pairs of shoes before he put the right ones on her feet. This shoe buying was turning into a struggle that she was determined to win, so when he picked up her foot in both hands and kissed the inside of her arch she almost hit him. Then when there was a mistake in the bill she did in fact yell at him, even though the mistake was in her favor.

*Shoe Store*

It simply did not cross her mind that he was trying to make a pass at her, not until she was sitting on her bed looking at the shoes in her closet door mirror. She practically did a back flip diving for the cover of her comforter. With her face sandwiched between two pillows she allowed her mind to reconstruct first his face and then his every movement. He looked like a skinny

Omar Sharif and his actions were so much those of a Prince Charming that Susan became terribly shy and for the next month used the bus stop five blocks away.

On January third, Susan was so late for work that she went to her regular bus stop hoping not to be noticed by the shoe store employees as the argumentative American with the manners of a porcupine. As soon as she arrived, however, Omar was out the door and onto the crosswalk where he wrestled down a taxi and dragged it to her feet. Susan couldn't move. The other people waiting for the bus began to smile and urged her to get into the cab. Finally the cabby said, "Lady, unless you're going out of state this guy's given me such a big tip that if you don't get in this cab I'm gonna put you in it myself."

That morning, instead of being late for work, Susan was early. She was also mortified, and vowed never to stand at that bus stop again. It wasn't that he did anything wrong, he didn't, except smile and wave and act like someone in love. It was her, she was the problem; it made her want to cry and at night she had been crying very softly to herself.

The next time she saw him was in the spring. It was raining and she had forgotten her umbrella. She saw him running down the street straight towards her with one in his hand. When he reached her he didn't say anything, just stood behind her holding the umbrella over her head. The bus came and everybody got on. When the bus left he was still standing there and so was she, but the rain did seem to be letting up.

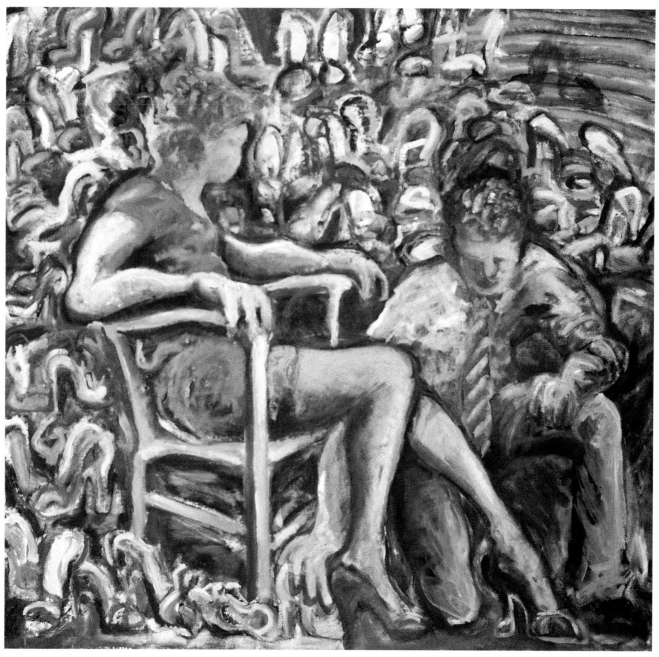

Shoe Store 2   *Oil   60"x 60"*   1986

LAURA'S HUSBAND WAS CHEATING on her but it didn't matter because she was cheating on him. L.A. was so great that way, so cool and chic, one didn't get upset any more, one just got even. Every morning Laura watched her husband get dressed in his Ralph Lauren pants and his Armani jackets, and every morning she thought what a jerk he was compared to Eric. She would listen to his Porsche purr pretentiously down the driveway, then wait for Eric's four-wheeler to squeal excitedly up the same driveway. Eric never used the front entrance, preferring to sneak around the garden to the bedroom's French doors where he could watch her as she lay in bed, before quietly stepping inside

## Dream Lover

and slowly pulling the covers off her body. They made love all over the house — on the floor, in the swimming pool, even accidentally in front of the maid who luckily spoke no English. Eric had this really muscular body and he knew how to do all this kinky stuff like tie her hands together with silk ribbons while he

RING...A groan escaped her lips as Eric's face scattered like a reflection on broken water...

RING...with a rush his skin pulled away from her, his eyes, his hair, his fingertips, all swirling down the open drain in the white sink of her skull...

RING...Laura picked up the phone.

"What's wrong with you? Are you sick?"

"Who is this?"

"Barbara! Your best friend? Remember, we're supposed to have lunch? It's one o'clock in the afternoon already. I'm at the restaurant, Laura, and you haven't even gotten out of bed. You're dreaming your life away."

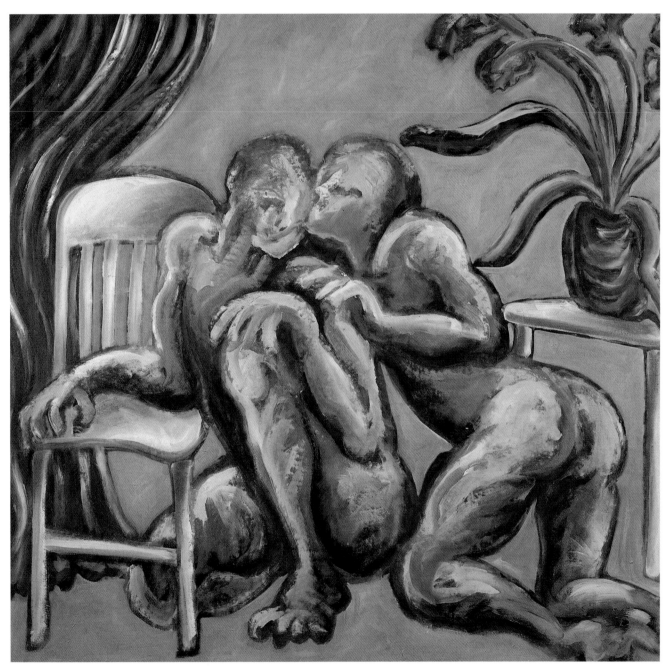

Love Crawls   *Oil   58"x 55"*   1989

## L.A. Housewife

SHE HAS JUST FINISHED pushing the chrome basket in the rat maze of food and packaging known as the supermarket. Now she's doing eighty in her car and the vegetables in the back seat are complaining. "We're wilting. We wanna go to the refrigerator. Take us home." "Shut up," she yells. Her knuckles and her lips are an odd sort of yellowish white. "I won't be obligated to a head of lettuce, do you hear me? 'Wash me off. Pat me dry. Now put me in the crisper,'" she mimics the lettuce in a high pitched snarl, as she careens into the parking lot of the Town House Bar on Sunset. "Get it through your head you're nothing but a godamn little ball of green shit, and I'm not carrying you to happy refrigerator land." She slams the car door. "You can all just die in those plastic body bags. In this heat it won't take more than an hour."

In the bar it is cool and dark. Men brush by her like great white sharks trying to sense the smallest hint of a come-on. She feels naked, vulnerable, like a lobster without its shell, and starts frantically digging in her purse like she wants to climb into it. When the bartender asks her if anything is wrong, she orders a Bloody Mary and sits perfectly still at the bottom of the bar, so the other fish will leave her alone. But it isn't any good, she can still hear the raspberries sobbing softly in the back seat of her car. "Fuck them, they're only two dollars a box," she says to the stranger next to her. He smiles showing a lot of teeth and slips his hand on to her knee. "Do you know the Howard Johnson's down the road?" she says to him.

Motel   Acrylic   72"x 72"   1984

108

Inside Out   *Oil*   70"x 75"   1984

SHE BEGAN NOTICING that every morning sand had formed in little piles at the threshold of her door. She didn't know where it was coming from, she was miles from the beach; perhaps L.A. was reverting back to being a desert, or the wind was slowly beginning its plan to bury L.A. alive. No one else seemed to notice it, but it made Betty visibly upset to see the insidious grains in the cracks of the pavement and piling up in mini-dunes against the building, so she hired a middle-aged Mexican to sweep her driveway every morning. Things were fine until he started bringing his girlfriend to work with him. This shy looking chunky girl would wait for him to finish, but sometimes as Betty watched them through the venetian blinds the man stopped working and they wrapped their arms around each other or snuggled up on Betty's lawn chair.

Meanwhile the sand kept coming back. Betty could hear it grinding under her shoes as she walked to the car and she complained bitterly to the man every morning. Soon he stopped bringing the girlfriend and there were no interruptions in the sound of steady sweeping that woke her up and

## Sand

accompanied her coffee, but still she complained about the sand. Now she found it along the window sills and on the linoleum floor of the kitchen. When she brought him into the house to show it to him he laid the broom against the counter and put his arms around her, and she felt the sun warm on her back like it had felt in Hawaii when Harry held her on their last vacation — but that was ridiculous, there was no sun, they were standing in the kitchen. His black mustache moved against her neck, and Betty pushed him away. "What do you think you are doing?" With dark innocent eyes the man shrugged. "I don't know what you want, lady. You pay me well but there is no sand, there never has been any sand. I sweep to keep you company, O.K.? You are very nice but too nervous, maybe *loco*, that's all." Betty fired him on the spot, and the next day there was so much sand in front of her door she was forced to climb out of the window. On the freeway the sand was everywhere, in patches at first, like laundry the wind had tossed around: socks, underwear, then sheets, then thick white blankets. When she stopped the car in the middle of the fast lane there was a tremendous crashing spinning sound. Someone had started the rinse cycle.

Yellow Memory   Acrylic   48"x 60"   1983

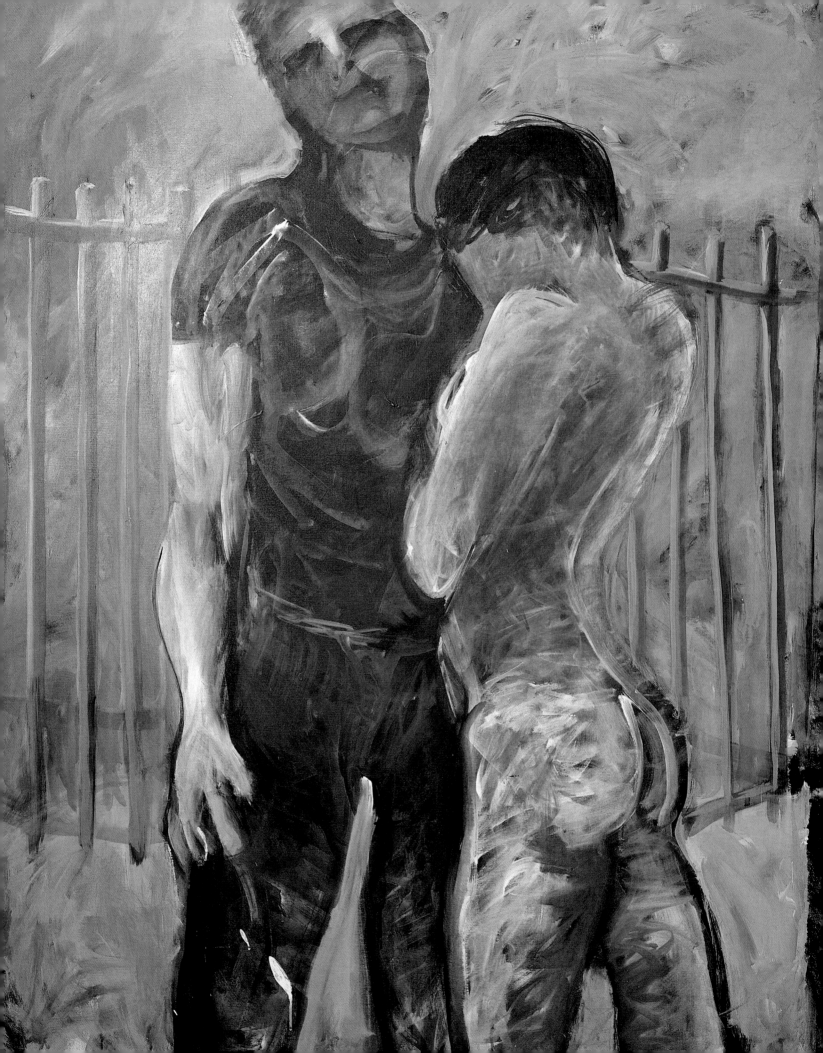

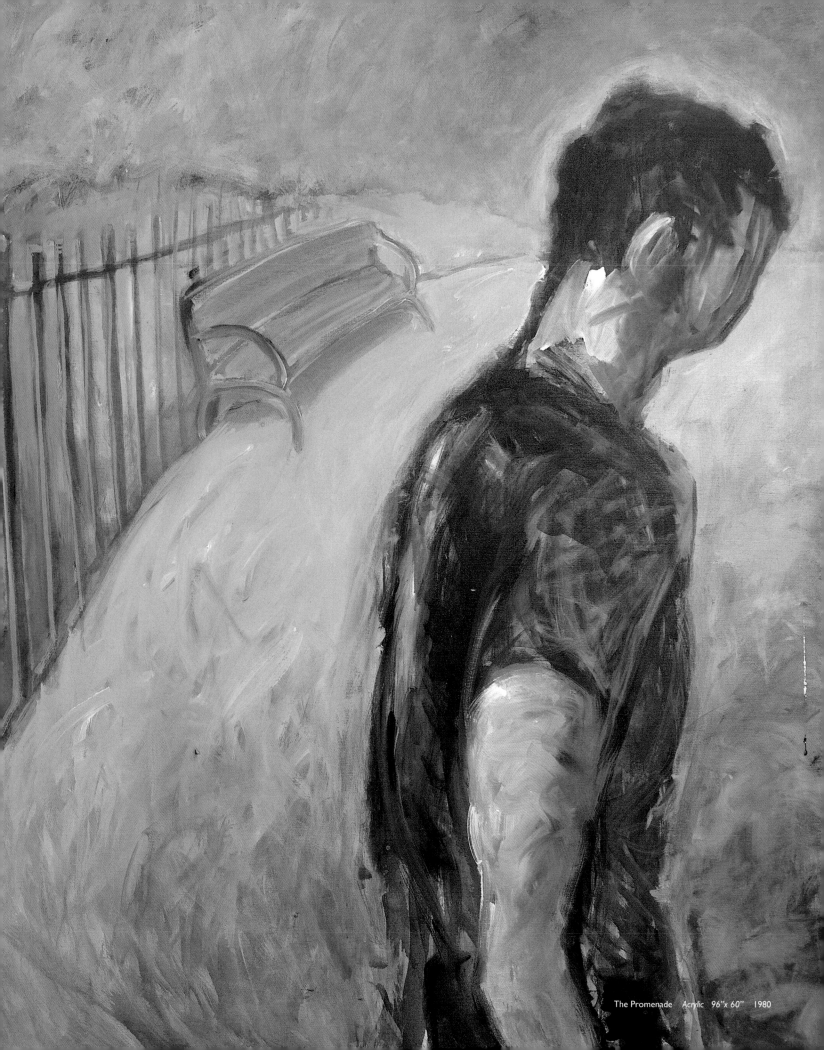

The Promenade   Acrylic   96"x 60"   1980

The Dealer   *Oil   51"x 73"*   1989

# 6

## HOLLYWOOD HANGOVER

THE APARTMENT on Western Avenue was in an old Spanish building with a balcony running around the courtyard. It was the epitome of decadence and extremely conducive to doing drugs, not so much because of its architecture, but because the upstairs tenant was a dealer. We partied heavily in this building — it was nothing to wake up in the morning and find the courtyard smeared with blood, bottles and staggering bimbos, or to find out that Hector had overdosed again, and when Carol brought him around he was so pissed off he said he would kill her if she ever did that again. Undoubtedly there were good times too, like the poker party when we all dressed up in high heels and bathing suits and shaved each others' heads. (I couldn't get a modeling job for months after that, but I still thought it was funny.) Then there was the time Jason bought a whole eighth of blow from that guy in the bathroom and did it all in one night without sharing it with us. When he was finished he came out with a bunch of extension cords in his hand, and tried to hang himself from the tree in front of the Winchell's Donut House across the street. We all brought out chairs and sunglasses

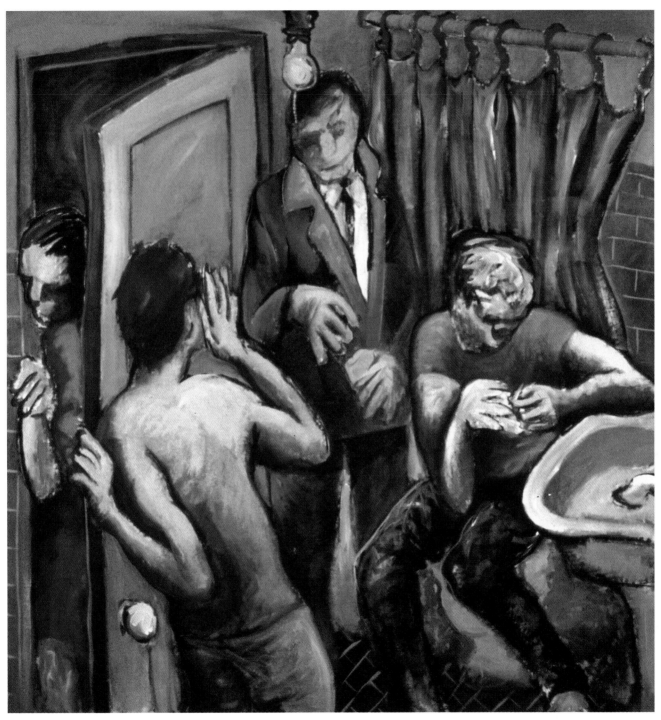

Dope Deal   *Acrylic*   70"x 72"   1984

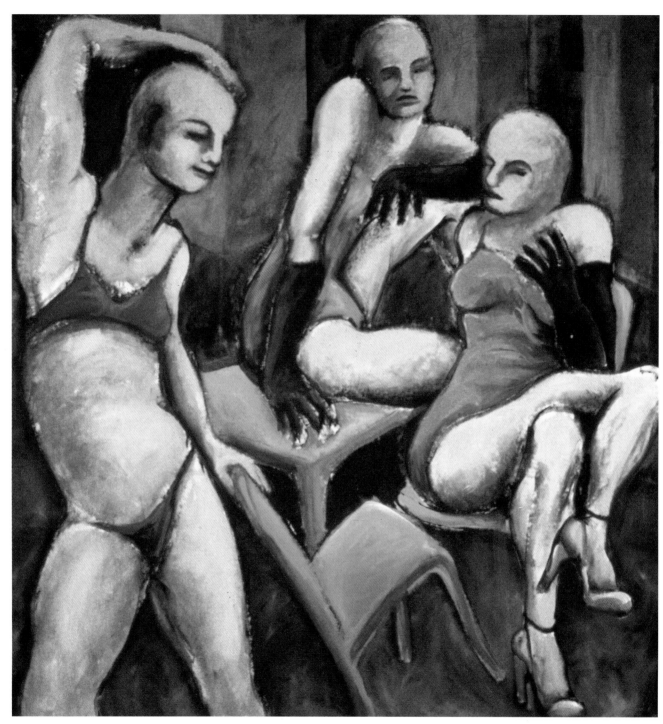

Wigged-Out   *Acrylic*   70"x 69"   1984

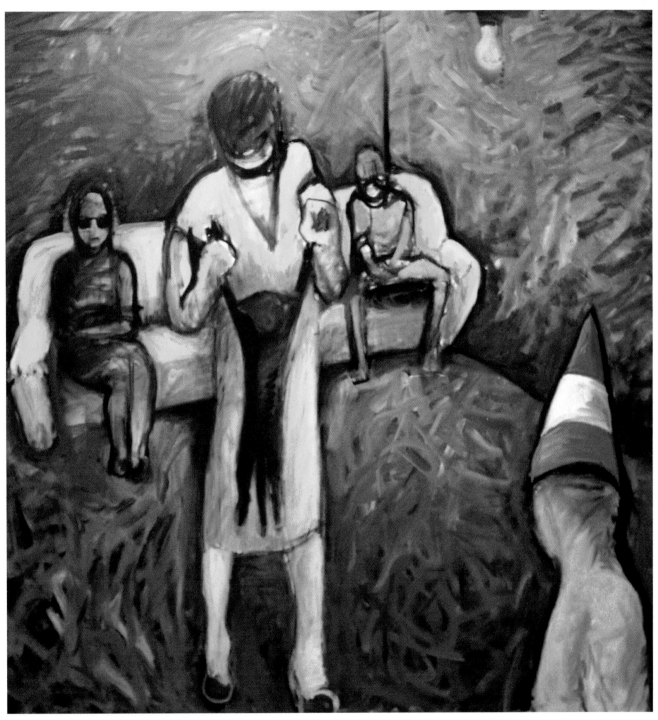

Is This Your Cat, Mr. Bigalow?   *Oil   54"x 54"*   1991

119

and sat down to watch him. That was pretty funny.
But the best time was the dead baby shower we
gave Bone on her fifth abortion. We presented her
boyfriend with an expired and closely shaven cat,
and a note from the doctor which said, "The human
race would appreciate it if you did not make any
more contributions." That was really funny.

Over all of this partying hung the nagging
fear for my only brother Tommy, who had fled to
Paris to hide from the family demon that chased us
both. Separated by the sea, I could do nothing but
wait for news. Was he in jail? Did someone rat on
him? Was he too skinny? Was he sick again?
Sometimes when I was totally straight I'd be sitting
there and the ghost of a high would creep over me,
and I could feel Tommy banging junk again. I
could feel the shit in his veins glowing like radium
in the government vaults of the earth, and his heart
fluttering in my throat just under my right ear. I'd
shut my eyes monitoring the faintest signals as he
flew blind over enemy territory, his plane out of
control. Next morning I'd call, and sure enough, he
had gotten high again.

My boyfriends were dealers, but my dealers
were never boyfriends, that was the rule. Cowboys,

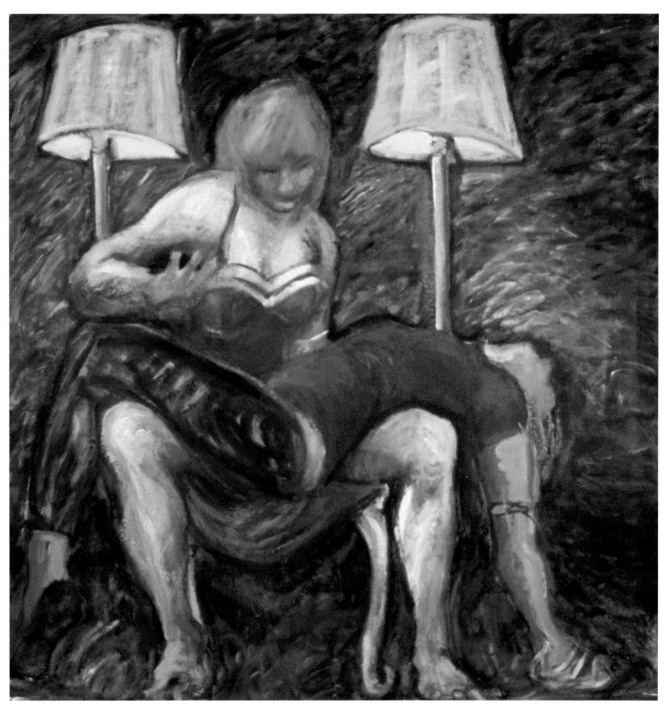

Suburban Pietà   *Oil*   72"x 72"   1985

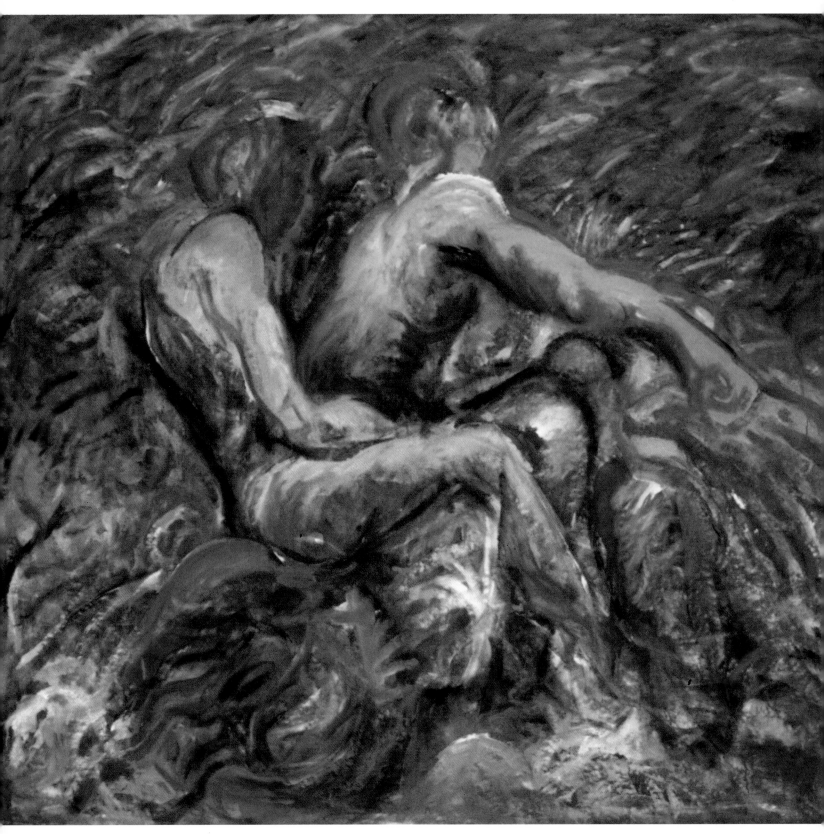

Uneasy Rider   *Oil   80"x 72"*   1986

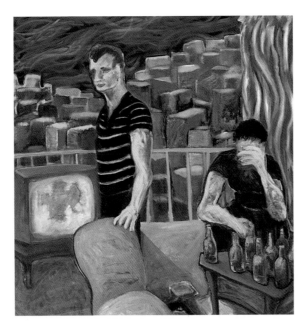

Apt. 12a    Oil    60"x 60"    1987

dealers, rock and rollers, who later would be
carried to their A.A. meetings on the iron
Valkyries of Harley Davidson as if to Valhalla, to
reminisce about how they had cheated on me.  So
what, I had cheated on them. They were pretty
interchangeable, either in debt, jail, or even
worse, bad bands.  A typical romantic night at
home would be the systematic destruction of the
apartment in search of an imagined envelope of
money or misplaced piece of mind — first the
ground search, the removal and shredding of the
carpeting, followed by the careful dismembering
of the furniture and a final disemboweling of the
couch which lay beached helplessly on the
wooden deck of the floor.  As grim as ocean
whalers we cut and removed the couch's fatty
stuffing in sections, pausing only to listen to the

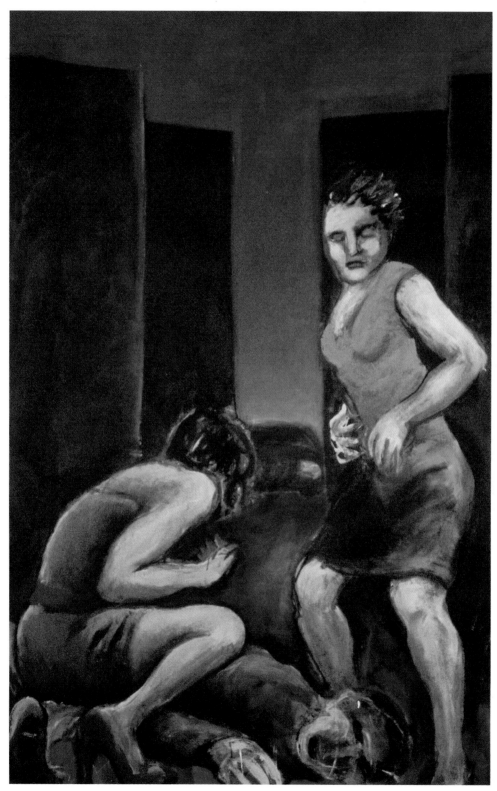

Vampires   Acrylic   49"x 74"   1984

mournful wail of a siren warning other couches deep in the city below of our unnatural presence.

My girlfriend's name was Jane. She lived next door and was dedicated to mindless partying and anything else that would keep reality at a minimum. I started running with her, through the brambles of the Hollywood punk scene. How was I to know that she was a vampire and I would become addicted to anonymous affection? After my first victim it was easy. I rose from his body with the taste for more in my mouth, and the hunt was on. We hunted systematically for victims, for stuff, for highs. We were on the pest list everywhere. We crashed art parties, devouring the food of hosts we never knew, we went to the ugliest bars before they were in, and followed the worst bands until they became famous. After a while we weren't really interested in finding anything, we just liked to hunt. If we didn't score we waited with the other zombies at The Zero, an after-hours club where you never knew if you were standing in beer or piss, you couldn't tell if the patrons were dancing or fighting, and the vicious door-person might let you in but you never got out. We worshipped at The Starwood,

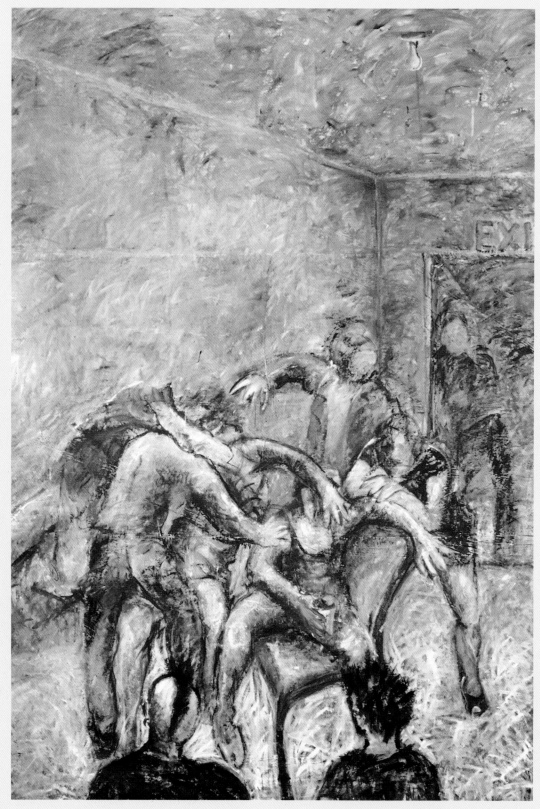

Zero One Club   *Acrylic*   86"x 108"   1983

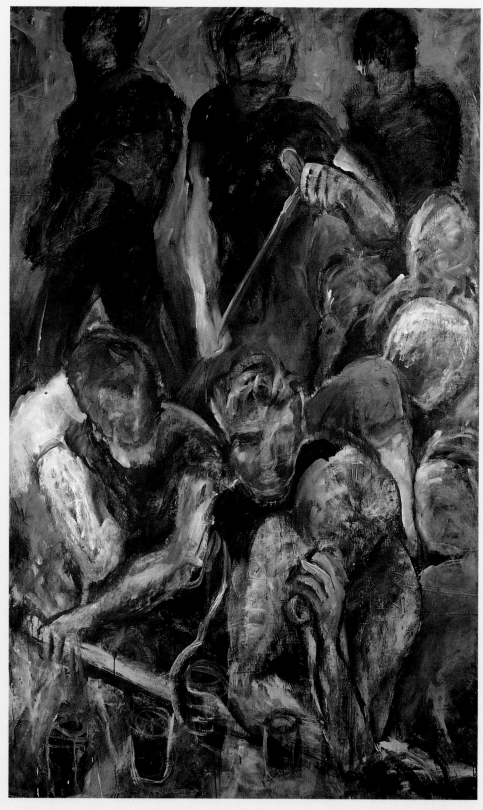

Club Lingerie   Acrylic   60"x 99"   1983

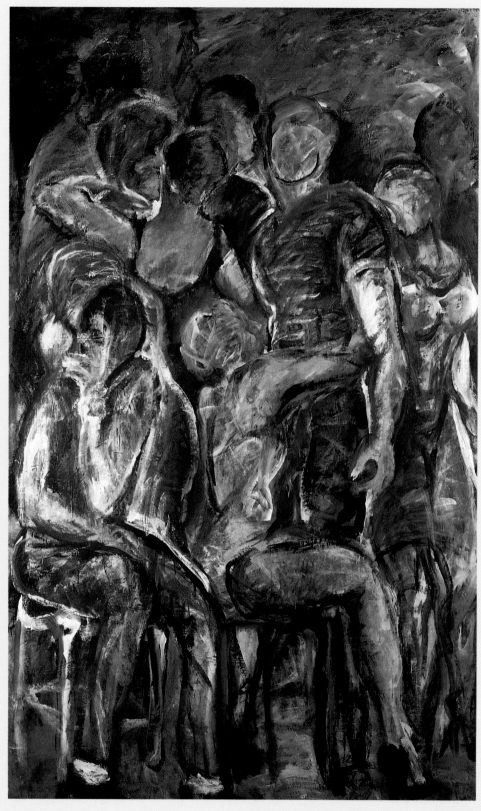

The Starwood Balcony    Acrylic    54"x 72"    1983

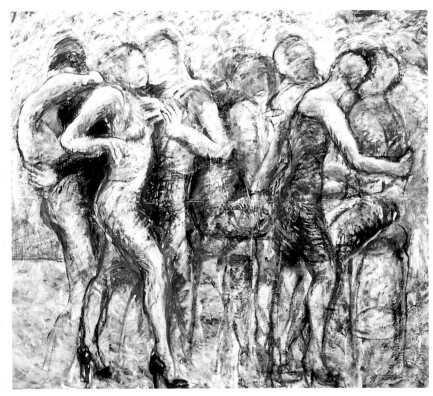

Art Party   *Acrylic   108"x 84"*   1983

standing on the balcony watching the mob of
punkers slam dance like a hundred-legged bug
turned on its back.  We haunted The Lingerie
where live bands played and live meat got
drunk at the bar, and we pretended we were
live too, but we weren't, we were high.  It was
difficult living with a habit that stood in the
parking lot screaming "more!" every time you
tried to get in your car to go home.  It was easier
to drown everything out with punk rock.

I thought vampires lived forever, and I
would too, as long as I was home before the
dawn cracked my eggshell hangover.  The
exposed yoke of the sun would rise fragilely at
first and then come smashing down on my head
like a busted chandelier.  Things were getting
really out of hand.  My skin cracked open and
sand poured out.  My breasts flattened, my face
caved in, and my mind slid out of my mouth
and lay fluttering on my pillow in an effort to
escape. Now, when I really needed to get high,
it was suddenly uncool to take drugs.  The scene
had dried up leaving drugs, tattoos and the
occasional mohawk stuck in the drain.  L.A.
rolled over in the smog and she wasn't very

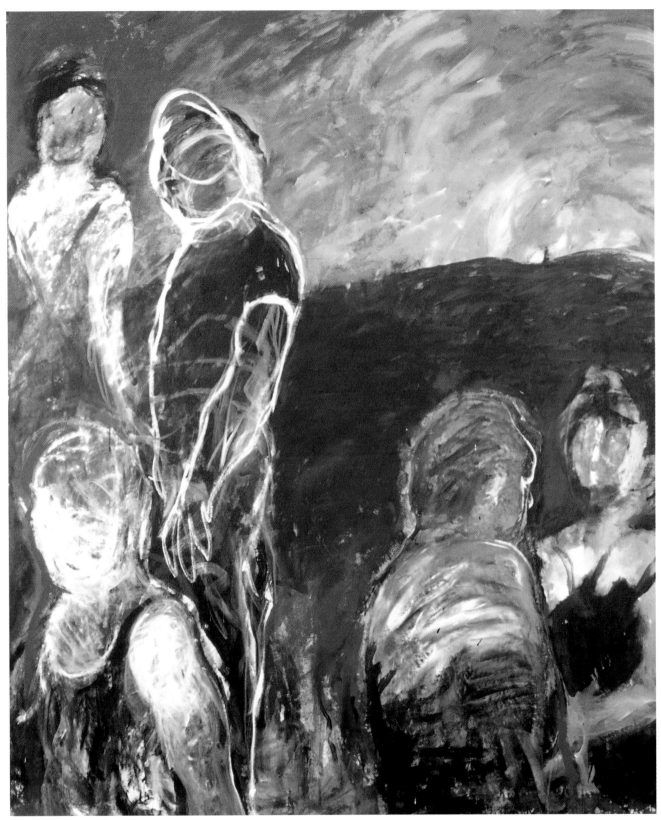

Red Death   *Acrylic*   72"x 84"   1984

pretty, not the paradise we had gone to bed with.

When we woke up the plague had hit, it was all over the news, The Red Death. We just stood around looking at each other, no longer able to touch or comfort each other in that animal way. People talked about the planet ending, the inevitable doom of the race. And then more and more you heard about a miraculous place far up in the Angeles Forest, about a pool of glowing water that could regenerate faith. It seemed like everyone was going up there to get baptized and cured of all their ills. Talk like that was a sure sign of the end, said the old men who sat all day in Winchell's Donut House. I had to move out of Western. Along with some wild costumes I didn't feel like wearing any more I left my image behind, lying in the bed like a one night stand. I knew she would get up in the morning, stumble over to Winchell's for coffee and try to remember where she'd parked the night before, so I left my beloved black Trans Am behind for her.

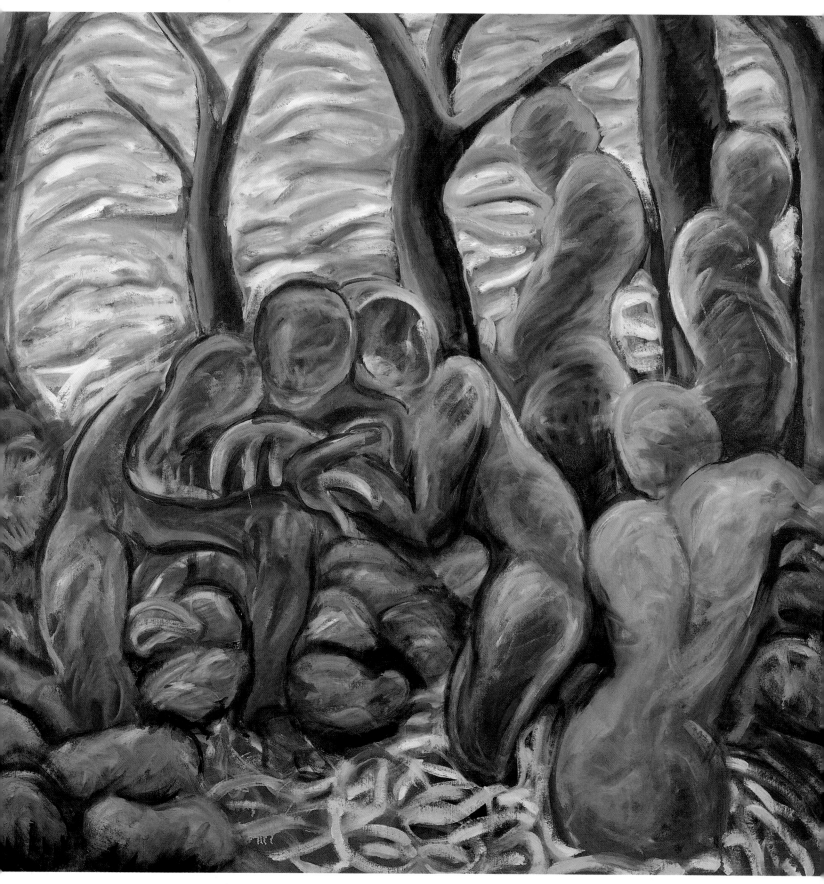

Baptism   *Oil*   64"x 62"   1988

One Night Stand   *Acrylic*   48"x 66"   1983

# 7

## O N E
## N I G H T
## S T A N D S

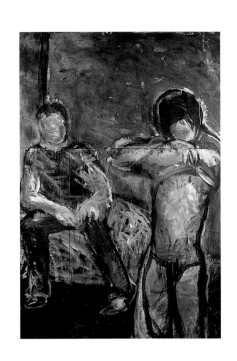

IT'S A NICE DAY in Orange County. I'm standing in line at the bank, waiting to see my money, and I feel nice and secure until the teller tells everyone to take off their clothes. I take mine off in an organized fashion, starting with the shoes and ending with the brassiere and pearl necklace, when I notice that the lady in front of me has removed her head along with her garments. She just takes it off and puts it down on the floor. People in the balcony start laughing at me. I try to tell them, I've been coming here for years. Every day I deposit a little Cheerios, and I have filled almost five deposit boxes.

*Shame*

A guard comes over and tells me my shopping cart is illegally parked. Things are no longer nice. "I live in a car," I yell at him, "I'm not homeless. I'm not a bag lady, I have a bar code, I'm not invisible."

I'm so mad I wake up only to wonder what kind of fool I was last night. My boyfriend Michael hands me a large Winchell's coffee from across the street and says simply, "Don't ask, you don't want to know."

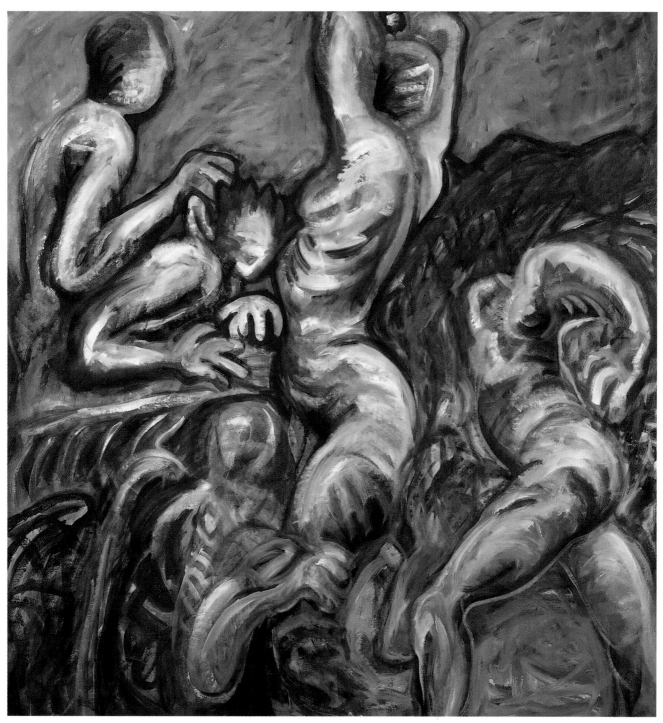

The Insane    *Oil    58"x 61"    1987*

I'm STANDING ON SAND but the light is electric, the air is conditioned and the sky is painted, like the set of a Fellini movie, or maybe a school Easter pageant, because all the boys are posing on giant crosses and all the girls surrounding them are supposed to look very sad at the foot of each cross. We keep stopping and starting because someone isn't doing it right.

## Absolution

Even though the desert is fake, it's hot and I'm uncomfortable — I don't know how long I can stand here when I suddenly realize that everyone is waiting for me, but I have no idea what I am doing wrong — they've got to tell me what I'm doing wrong, don't they?

Hearing the toilet flush I think to myself, if he takes a shower he's married. Within seconds the water is running and I close my eyes... It's too late, I missed the shot — I can't believe they did it without me, but everybody is gone and just empty crosses are left, acres of them like a cemetery. So what, I think, I never was good at faking tears, and frankly I don't care if he feels guilty.

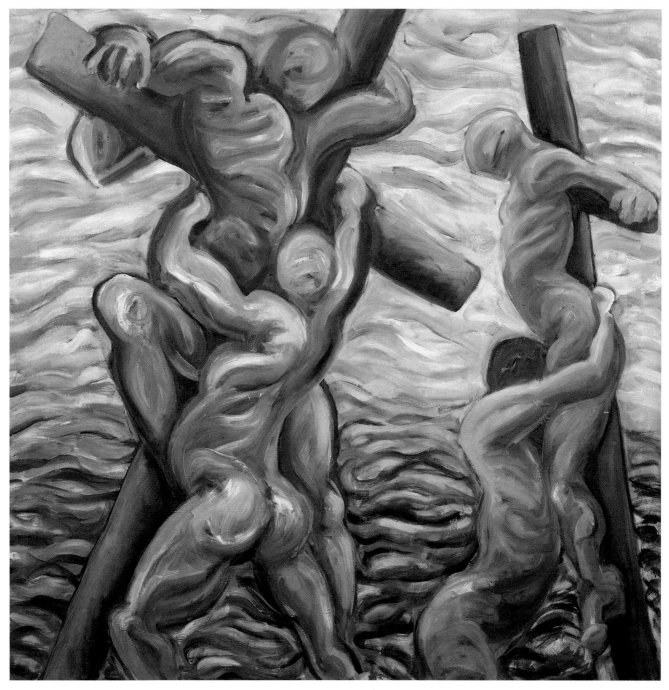

Double Cross    *Oil*    46"x 46"    1990

THE ROOM IS BEAUTIFUL, all rubies and gold that flicker and burst into flame. My family is in there, I can hear them screaming but I won't go in and rescue them. I move down the hallway, past the silver and sapphire room which is really frozen water and if I scrape the surface I can see my English teacher floating in there. The room I end up in is covered in emeralds and copper that grow and blossom as soon as I close the door until I'm in a steaming

*Jungle* jungle. My boyfriend sits on a porch watching TV. I want to leave but I can't find the door. He says if I don't stay on the porch the hunters will skin us alive — I think he's teasing but I'm afraid too. He's telling me stories so I'll stay with him, and now I'm afraid of falling off the porch.

I'm lying next to my old boyfriend Michael. His bed is too small and I have to make him move over. He always takes me back and I always leave.

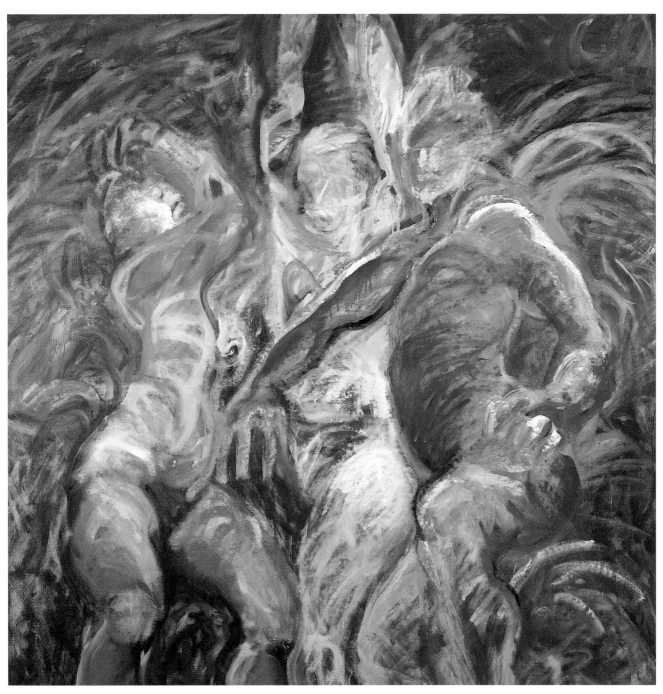

They Took George Into The Woods and Tortured Him For Several Hours
*Oil   58"x 58"*   1986

**HEARING HER FOOTSTEPS** on the stairs I frantically try to put the planets back in the sky, but I cannot remember the order, and the earth falls to the floor. Two stone gargoyles jump to life as she opens the door. Her dragon's breath burns my cheeks. Placing the world on her desk where it wobbles sadly to one side she hisses, "It's out of balance and it's your fault." Her lips curl back from a row of pointed teeth I have never seen before and fear tightens the skin on my head. "I told you not to play with the planets." Ripping

## Child's Play

back the curtain of the sky and leaving it to flap in the wind she reaches into the velvet darkness and takes out two demons from her best collection. They sit on her lap licking her fingers and spitting down on my head. How I hate them, but there's nothing I can do. She lets them have my toy, which they proceed to tear to shreds.

The kid sleeping next to me must still be in his twenties. I run my tongue along my teeth to see if they have gone pointed in the night.

Demons  *Oil*  60"x 61"  1987

THE PLAYGROUND BEGINS SPINNING around, empty swings cutting through the air, seesaws balancing imaginary weights, and the sand sloshing in and out of its box. The placid mothers of the park at first look sick, then drunk. Janet Post jumps up and screams, "Kill her, Bobby!" Pat Andrews grips the handles of her pram and starts chanting, "Hit him, hit him, hit him." Beryl Kinsky, letting go of an incredible war whoop, shouts to her daughter, "Get him, Lynny, now bite him!" I can see the children don't know how to

*Playground*

respond. They just giggle and pretend to hit each other, but then Joey shoves Annie hard into the dirt, and Marsha bites Jonathan on the arm, and Glen smacks Marsha in the head with his new shovel. Soon they are a frenzied pile of little fists and feet all crying and screaming with their moms egging them on like at a cockfight. Blood pours onto the ground until the playground stops twisting and turning, and all I can hear is the devil laughing in the bushes over by the gate. I can't even get out of bed I'm so fucking nauseous. Shit, don't let me be pregnant.

Playground   *Oil   60"x 60"*   1988

I CAN FLY. It's such an incredible feeling. Better than drugs or sex, better than being young and beautiful, but with those words I get stuck as if in a giant cobweb and I cannot move. I am pinned to the ground by this girl sitting on my chest, whose skin is a luminous green. She slides her hand into my flesh and pulls out my heart. We both look at it in awe. She drops it to the ground where it looks like an old dinner roll lying in the dust and I wonder what I ever needed it for in the first place. I'm relieved I don't have it any more. I hear a

## Flying

snake in the tree, he's laughing at me but I don't care. My father wears a beehive and my mother has a dog's head, but it's all right, I don't have to talk to them — I can fly again right into the mouth of the whale, his throat is like a cathedral of flesh and blood. From out of the gullet comes the Virgin. She opens up her stomach and an endless snake slithers out. I want to fly again. I've got to fly away.

His shoulders are completely covered in tattoos which rise and fall against the patterned sheets like a snake moving in the grass.

Virgin Birth   *Oil*   54"x 54"   1991

Green Vampire    *Oil    54"x 54"*    1991

THE GROUND is yellow, pitted and marked by the shreds of struggle and the stains of previous maulings. It looks like the plate of a giant after he's eaten, bones are everywhere and the dirt is smeared around like sour gravy. Little

*Ice Man*   pools of shrieks and cries shimmer on the ground before they join together in a river of the screaming wind. No one is allowed here.

Some stumble here by accident, shaking on adrenaline, but he came here out of curiosity, and now like a criminal he comes back here all the time just for kicks.

Shifting under the sheets, my arm bumps into another elbow. Across the pillow he opens his eyes — it's like seeing through binoculars in reverse. Each iris is the color of yellow dirt swirling around a black center, the spot in the labyrinth where the beast is always waiting. By his head I can see the handle of his gun on the table by the bed.

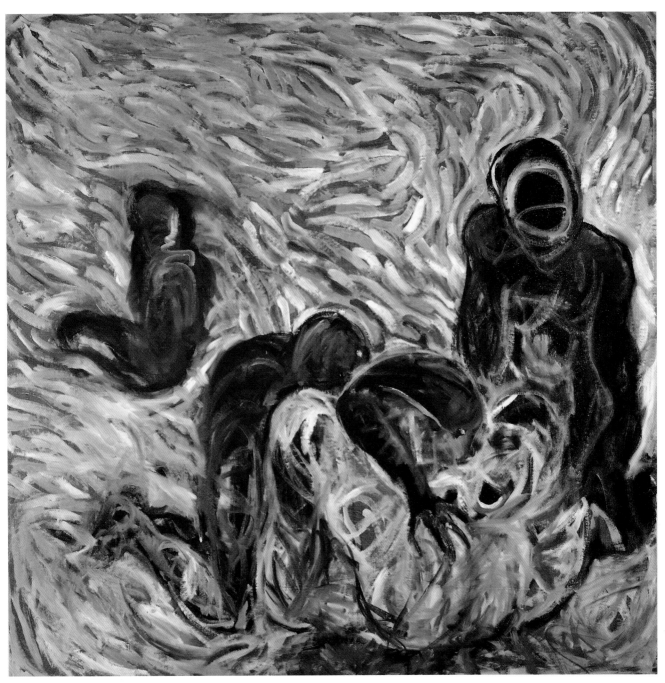

Murderers  *Oil*  72"x 72"  1989

I DREAM about not waking up, not even when this guy blasts on this horn so loud that the birds fall out of the sky and all motion stops so that the plants

*Stranger* turn to stone.  But still I don't wake up, not even when the devil calls my soul and it's led away by someone with a bird's head, and I'm left there by myself pretending to sleep.  I have to figure out where I am, remember how I got here.

I have no idea who's in bed next to me — but worst of all I don't know where I've parked my car, or, for that matter, if I still own one.

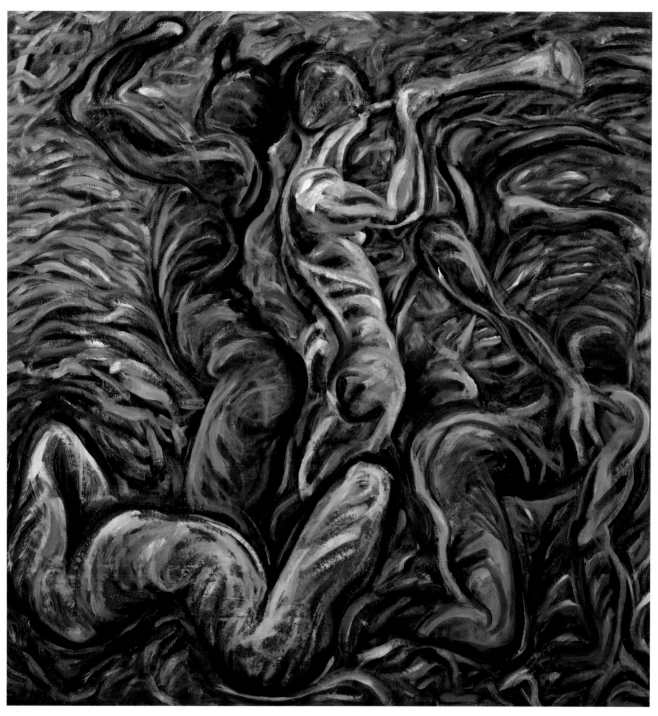

Judgment Day   *Oil   59"x 61"*   1988

Jane   Acrylic   42"x 72"   1984

# 8

## WHITE PLAINS OF WESTERN AVE.

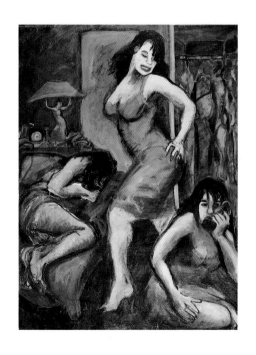

MY FRIEND, JANE, is flipping out, but she doesn't know it yet. One of those subterranean flip-outs, where you think everything is fine, but actually there is this volcanic pimple, the size of China, growing happily in one of the brain cells you've been avoiding. There it is, calmly eating an emotional breakfast off the lining of your skull. Other people are the first to notice. They are really helpful. "Shouldn't you fix that?," they ask. By this time breakfast is over for your new friend, the neurosis, and it's butt-fucking your whole life in a temper tantrum. "Shouldn't you have someone look at that?" Yeah, sure, let's take the one thing I don't wanna see and put it under this big magnifying glass. "What problem?" you scream wildly. This is where you cannot take any, and I mean not even the slightest weeny bit of criticism. Your friends back off, and hand out menus for the up and coming side show. They discuss, over the phone, the numerous ways your shit's gonna hit the fan. I know, I just got off the phone with Marion, and all we did was talk about Jane.

Jane's problem is men. (Hollywood has no other female problems.) You see, Jane lives casually with this dealer upstairs. When I say casually, I mean she cheats on him all the time. She cheats on him because she loves him, because he might cheat on her, and that would just kill her. But he never did cheat on her. Instead, he woke up yesterday and announced that he was leaving her for another country — going back to India or Saigon or wherever he started his spurious professions, for one last

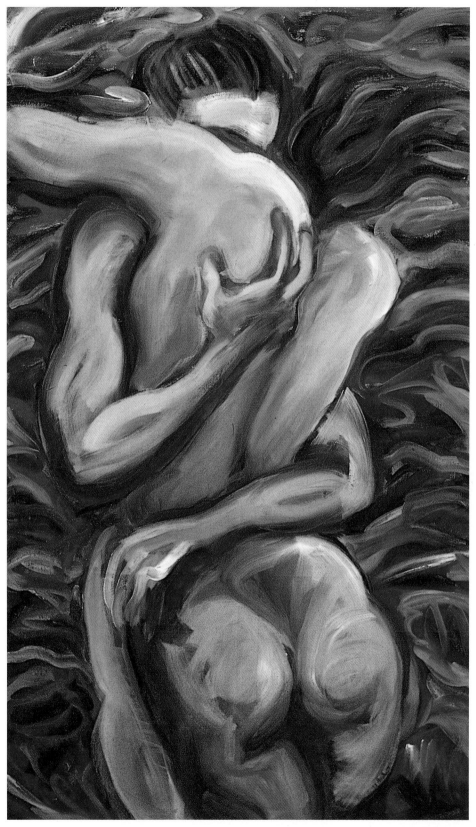

Lust   *Oil   36"x 48"*   1988

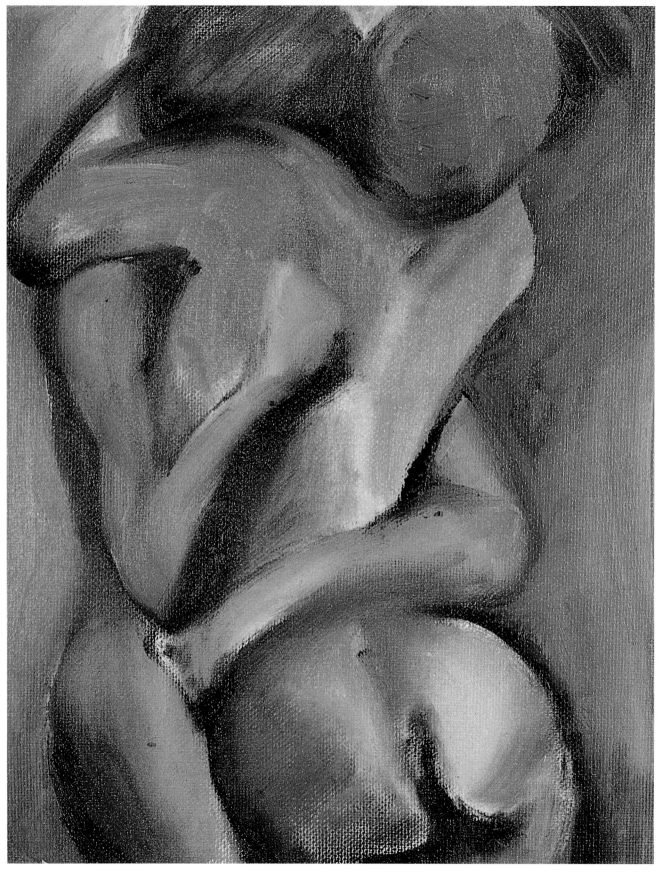

Craving   *Oil   8"x 10"   1987*

fling, before he was too old, before it got too hot, just before, that's all. A girl just can't plan ahead any more. It really is a major insult to realize that even though the guy loves you, he'd rather sleep with the Himalayas. I mean, compared to a mountain range any girl is bound to feel like a pile of pebbles, just another big broken-hearted boulder in the L.A. landslide.

Jane is rattling around on some very thin ice now, and it's beginning to snow. It's the beginning of a blizzard called "Abandonment." He's leaving — your Dad, your husband, your brothers, your sons — all of them getting up and walking away. And then you wake up one morning and no one is there, just soundless snow stretching for miles all around, and your voice is a little black squeak, and your body is that little National Geographic guy trudging through a heartless Antarctica. Yeah, good luck. They don't make snowsuits to protect you from that one. All those mittens and mufflers people offer you don't make sense any more. "Here, honey, you're better off without him." "Oh no," Jane groans, "not another pair of earmuffs." Her lips are blue and snow starts falling quietly inside her eyes.

So, just for laughs, I tell her I'm moving to New York, which is totally ridiculous. I can't even get out of bed in the morning. But Jane's so fucked up she believes me, and looks even more left out, if that's possible. Bad joke, I know, but I never said I was a good friend. No, no, no, I'm just as insecure as Jane. That's why we're friends. If you've

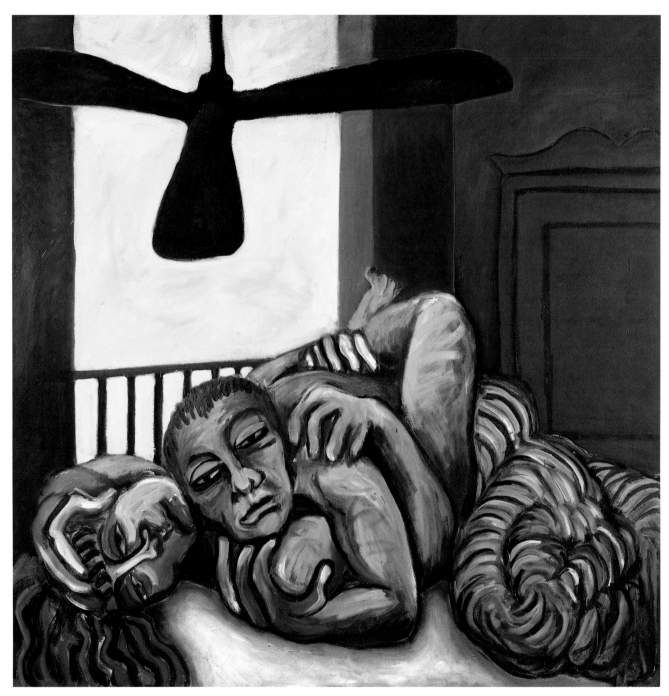

Anxiety   *Oil   54"x 54"*   1991

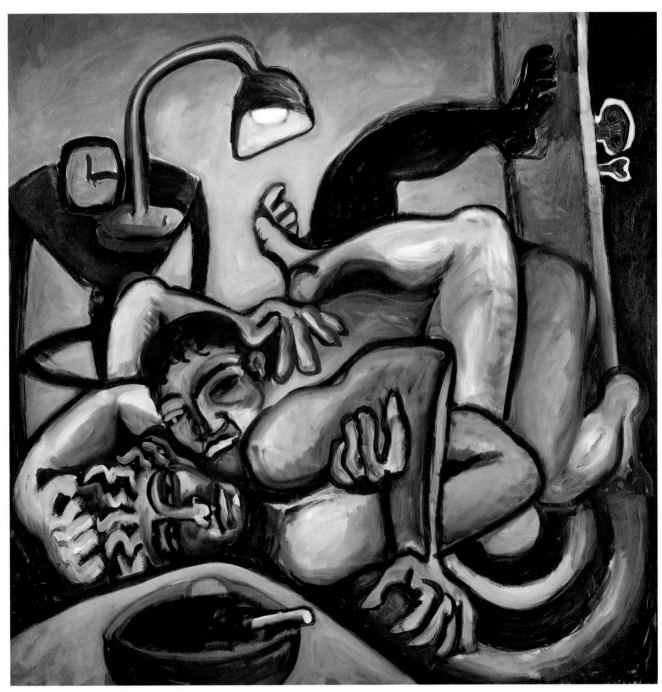

Guilt  *Oil*  *54"x 54"*  1991

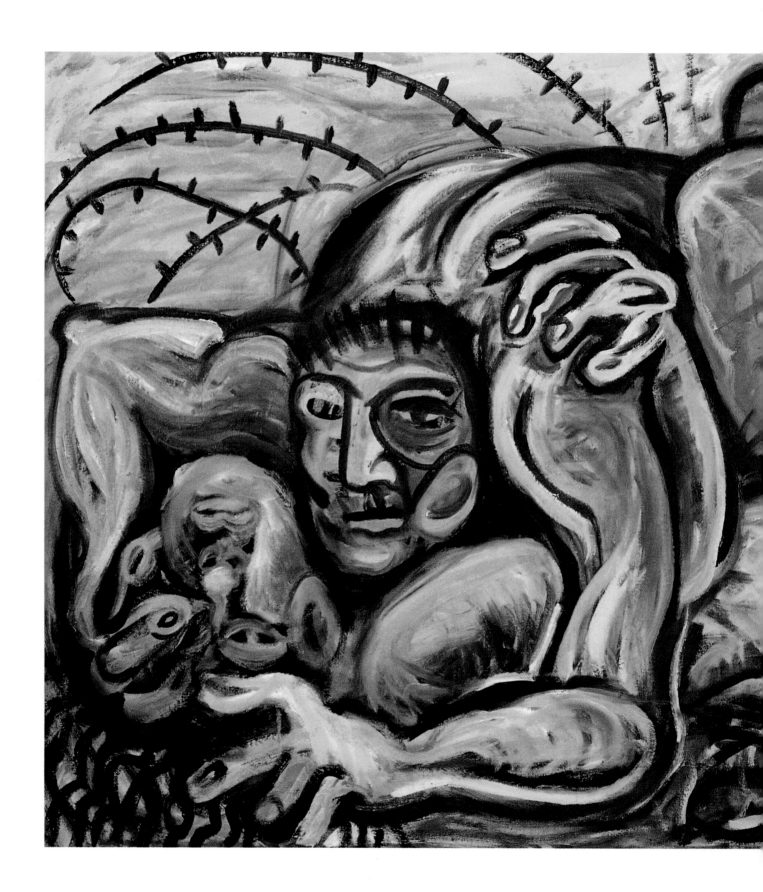

Depression    *Oil    52"x 36"*    1991

got damaged fur, you don't go lounge around with the ranch-fed minks. Hell, no, you run over to the slightly mangled squirrel colony. If I were married with kids, I'd be in the beaver pond, up to my ass in dishwater, happily making mud and wicker walled condos. Things could be worse, like playing golf with the Orange County gerbils, or hanging with junky rats downtown. But I don't have a fat ass. I have sleek little squirrel cheeks, and I don't play golf. And I don't shoot junk... anymore. Things are looking up — I'm a bimbo now. Me and Jane and my friends are single women, Hollywood squirrels with big pretty tails, jumping wildly from party to party, tree to tree, man to man. We're a very excitable rodent group, we are, very scattered, totally terrorized about being left out, left off the list. You try hitting five trees a night, it's a fucking nightmare. But now we are not so terrorized. We are very quiet, very still, in the eye of the storm because one of our group is about to get flushed down the toilet.

Yeah, we're plugged in alright, fucking mesmerized. We stop everything as we watch Jane try and outrun the coyote. Once you see the coyote, it chases you

Pain   *Oil*   48"x 36"   1991

forever, right into the straitjacket. But now it's busy ripping Jane's legs off, good — so long as it's not after us. Slam into enough trees head first, and this is how you think. I'm serious. The only time you feel safe is when one of your group is squeaking in pain. Me and my girlfriends, we are very frightened of the coyote. He looks for the weakest one and cuts you down, ships you home to Monster Mom, a family sacrifice, and won't let you out again until Mom croaks. By then it's too late to go to parties — this is bad news for a squirrel. Almost as bad as old age, another bag of worms we are busy face-lifting our way out of. We hover around nibbling poison security biscuits, and watch Jane fall apart. I look into Marion's "concerned" eyes. Jesus, this bitch's brain pan is just as fucking shaky as Jane's, which means her coyote is just around the corner. I look at Marion's eyes again. Scary. Her coyote must be taking a nap, he's definitely asleep on the job. We whisper over the phone, discuss Jane over lunch, and nod behind her back, then lie to her face.

I have to hang up. I feel shitty. I can't talk about Jane any more. It's too rude, too mean. Let's face it, women have about as much compassion for each other as turds. It's really fucked up. I mean I'm beginning to feel bad about this shit, and I hate it when I have to feel bad. I've got enough fucking problems. So stomp, stomp, stomp, I march right over to Jane's apartment. I'm so mad, I think if she's crying I'll slap her like they do in the movies. But Jane's not crying. She's happy, her mind is missing. She's looking for

it somewhere in her bedroom — in her purse, which is busy vomiting all over the floor, in her closet, recently redecorated by dynamite, in the cookie jar, which now contains the front end of her cat. In other words, the place is a mess, and Jane is smiling like she's had a lobotomy. "I've been laughing at my old phone messages. There's a great one of yours insisting that you're about to commit suicide, but you wanna go to lunch first." I think, what's so funny about that? Maybe Jane's gone mad. I look around. The TV is in bed having a conversation with itself under a quilt. "Are you high?" I ask, breaking my neck over the telephone. I sit down on a lot of make-up in a chair and stare at the typewriter, which happens to be dressed in a pair of pantyhose and one of Jane's bras. "No," she says, "I just got a job interviewing Hockney." Of course, I would have given my right arm just to be in the same amphitheater as Hockney. She continues on, "I had a great time last night, where were you... bla, bla, bla." I think, fuck this sorry stuff, Jane's having a good time. She looks a little fractured, a little overexposed, that's all. What do I know? So I left.

I came back too late, the ambulance was also too late, and the neighbors told me the police were calling it suicide. That's when I realized it was snowing, soundless white stuff sifting through the ugly palm trees, piling up around her door in the bright L.A. sunshine. Snow, stretching out forever across Western Avenue, from downtown to the beach, and over it I could see coyotes running, lots of them, and they could see me.

Suicide  *Oil*  *54"x 54"*  1991

Aftermath   *Oil*   72"x 72"   1988

# 9

# AFTERMA✝H

AT FIRST the picnic looked like an after lunch massacre — flies buzzing on the remaining food, bodies flung out over the grass — the only thing missing was the blood. The four of us who weren't sleepy went exploring over the hills. It was hot. Instead of blue the sky was as yellow as the eye of a brontosaurus,

## California Snow

unblinking and inhuman, staring at us as we crawled across his brushy hide like an expedition of drunken fleas. Wandering over what I assumed to be his left knee joint, we were mystified to find that it had started snowing in the negative — they call it California Snow. Giant black cinders floated from the sky, a blizzard in black nursed along by the warm Santa Ana wind, who like her sister, the Sirocco, could drive men crazy.

I was the first one to see the fire like a red tongue licking the hillside next to us. It didn't seem very dangerous or very big for that matter, but what I didn't know was that it could jump wherever it wanted. As we ran from the ragged little blaze behind us the hillside in front of us lit up in bright new flames. An angry iron helicopter grew out of a speck in the sky and a voice ordered us to walk calmly to our left, as if we were on the set of a Vietnam movie. As we waited for the jeeps to pick us up I watched the battlefield — fire in her red dress running about like a lunatic and man methodically surrounding and destroying her. I was surprised to find myself rooting for the fire, much the same way I used to hope for a car wreck on those hot days at the track.

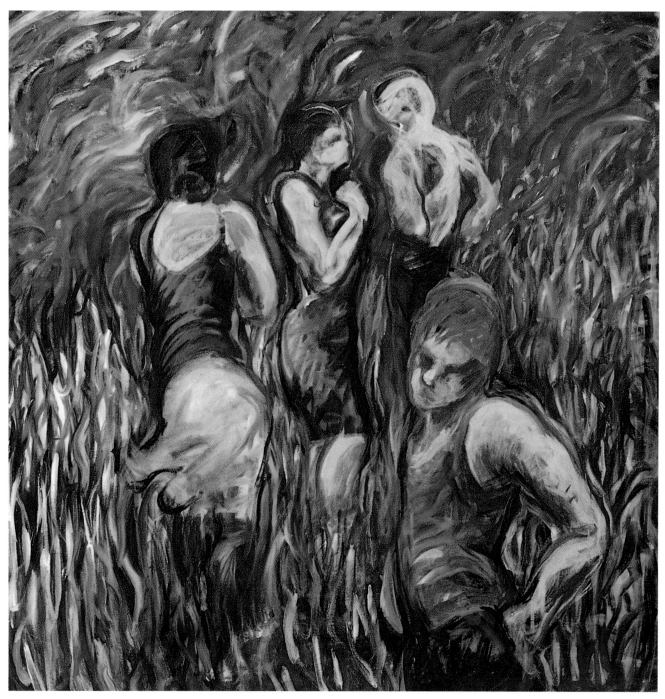

California Snow   *Oil   60"x 60"*   1988

OSCAR COULD CREATE the look, the most outlandish outfits, but when it came to putting on those heels, he really didn't have the glamour. His three roommates did, they could transform themselves into Maria Montez clones, and the apartment into a torrid jungle that melted the New York winter away. When Tony was finished with his make-up, a salad bowl looked like a Dior hat on his head. Oscar made

## Needles and Knives

dresses for them that were brilliant, impossible dresses with live birds to hold up the train, with so much ornamentation that Andy was once mistaken in the lobby for an Xmas tree. Meticulously Oscar documented every creation with Polaroids.

They were all awkward boys from the same Ohio town and it wasn't long before Oscar realized that Tony, Andy, and Mark could never go home again. Tanya, Adele, and Sonia could, but nobody would recognize them. Of course they never really were women, and this thorn in their side became the hook that pulled them out of the water of make believe and threw them belly up on metal

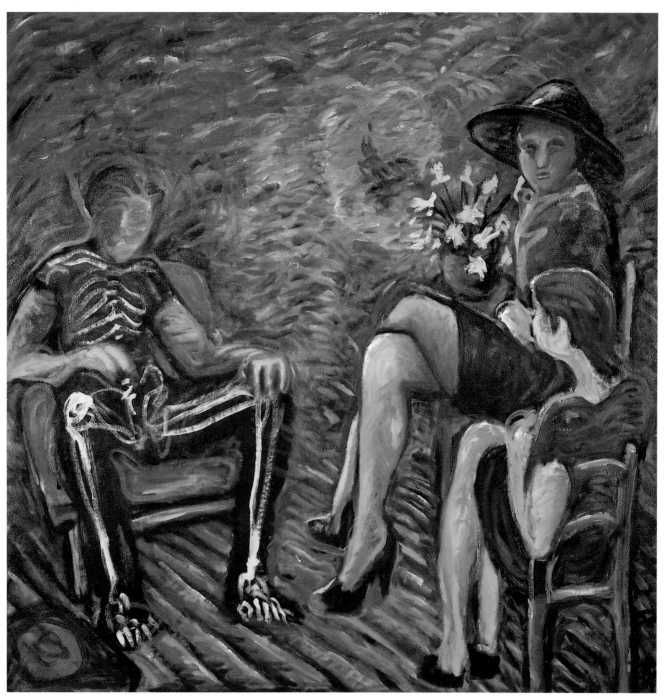

Red Room 2   *Oil   60"x 60"*   1989

hospital beds. Friends started calling them hospital junkies. The next operation would always be the one, but instead it just broke off another piece of the original mold. Dutifully Oscar kept taking Polaroids, no longer of glamorous eyelashes and feathers, but of gruesome implants of breasts, lips, hips, and cheeks.

He was designing costumes for Broadway when Andy died of complications. Since he had to see his parents anyway, Oscar went back home for the funeral. Andy's mother smiled as he approached the open coffin. Inside she had erased every hint of femininity, and on his upper lip she had nailed a mustache the same way the victorious army plants its flag to reclaim lost territory.

Two years later Mark died; confused by so many operations his body was plagued by strange pains, and he overdosed. Oscar paid for his funeral and this time it was properly done. After the service Tanya and her husband said they were moving to a small town in the Midwest where no one would ever dream she was anything but a housewife. Every year she sent Oscar a Polaroid of himself — she was aging nicely Oscar thought, very nicely.

Hospital Room 2   *Oil*   *34"x 45"*   1990

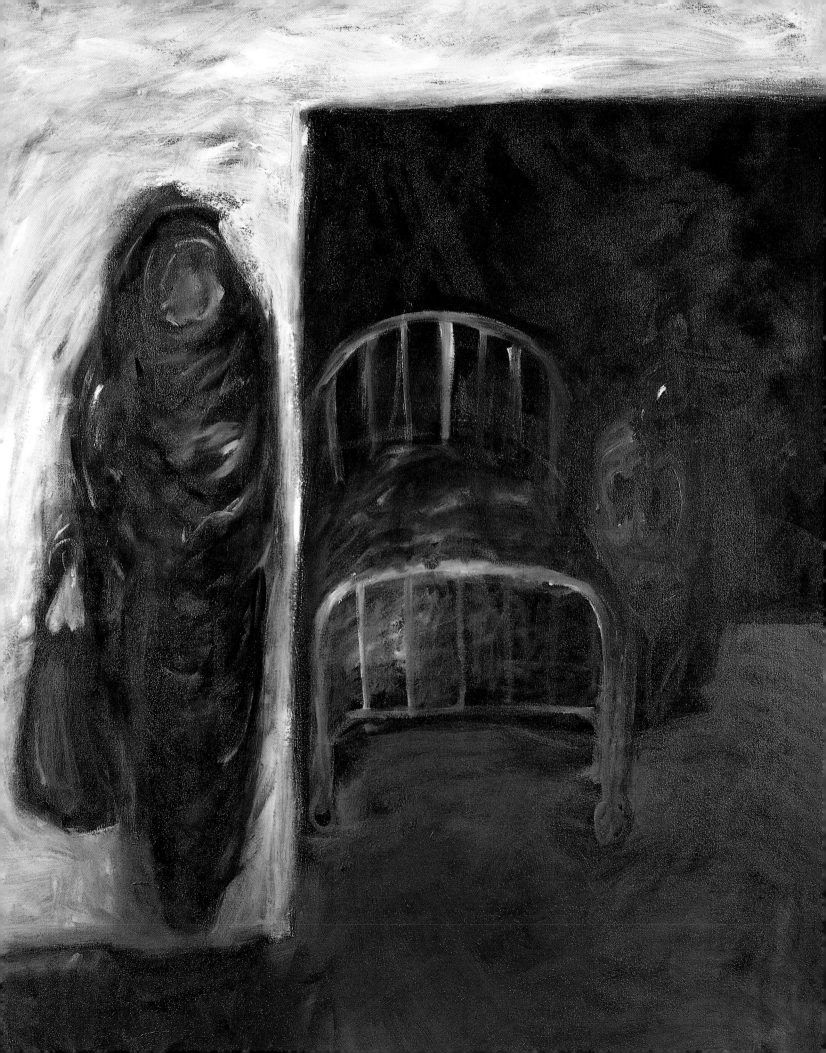

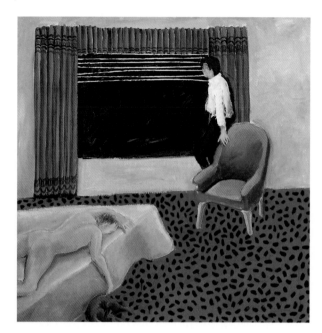

Santa Monica 1   *Acrylic*   48"x 48"   1981

YEARS AGO an old buddy from my drug days called me up to let me know that a really good friend of ours had passed away.  He had been found in a hotel room dead from an overdose, but since we had been such good friends she wanted to tell me that it was a suicide, and that his lover had administered the shot.  Apparently he had a new disease that attacked only homosexuals and

*Overdose* drug users.  At this point in our conversation I think I asked her if she was high because I had never heard of a disease attacking only certain people, and although I hadn't seen him in years I was not prepared to hear that my friend was dead.  Of course she was high, she replied, but didn't I know that the government had invented this disease to erase undesirables?  Whereupon I screamed at her that I wished to hell there *was* a disease like that, because I didn't want to hear that our friend had fucked up and thrown his life away over a stupid greedy high.  Then I hung up.

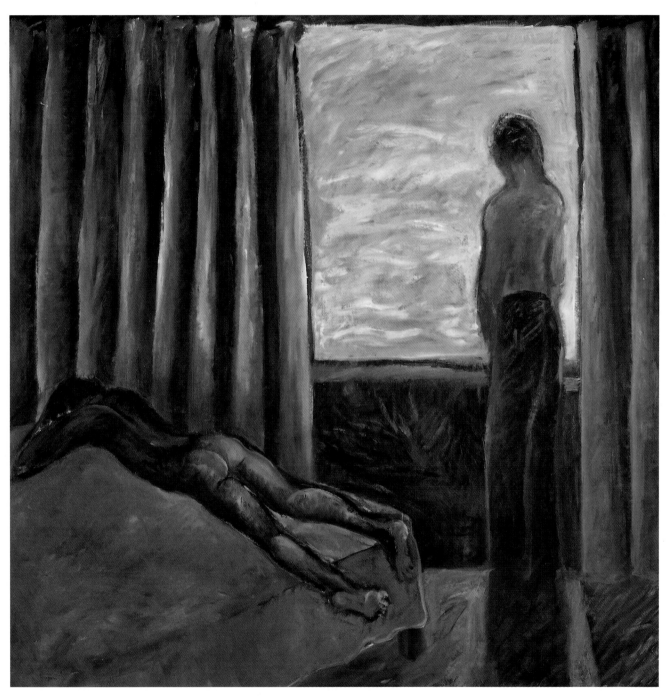

Santa Monica 2   *Oil*   60"x 60"   1990

HE COMES whether you like it or not, walking steadily down the path to your door.  In his hands are two baskets: one for your body and one for your soul.  My lover Mark, of course, has no idea who he is and invites him in.  I can't believe what a brainless bitch he is.  At first the stranger is shy, after all, people don't often make him welcome, they usually try to avoid him by whatever surgery they can.  Now he takes a seat at our table.  I am mesmerized by how white and beautiful his skin is.  His dark shadowed eyes ignore me and stare at my lover with the fascination and jealousy of an alien world.  I can see he wants to hold him.  He apologizes, saying he was

*The Visitor*  looking for someone else, but Mark begs him to stay for dinner. All through the meal Mark complains bitterly about his life and about the plague and the planet and the pollution, but he's also flirting.  I've heard it so many times before, he goes on and on late into the night, the month-old pain in my chest miraculously subsiding, and I guess I fell asleep on the couch.

When I woke up the apartment was freezing.  I knew something was struggling, without sound or hope like a bird in a cat's mouth.  I went to the bedroom and found them on the bed.  He lay on Mark, black and heavy, his arms around his chest and waist.  As I tried to pull him off, he snarled like an animal being ripped away from its food.  Be careful, he grinned, I actually came here looking for you.

Visitor   *Oil   54"x 54"*   1991

Prisoner  *Oil*  48"x 48"  1988

A DREAM used to wake my boyfriend up every night. When I asked him to tell it to me he told me this story instead. He didn't say it happened to him and I didn't ask.

Jackson's mother took in wash in Alabama. That's all the troop knew about her, but she must have been a strong woman because Jackson didn't kill women, even if he was ordered to. They told him the story of the beautiful Asian girl running up to the soldiers screaming "help" and holding her baby

*Boyfriend's Tale*   which she detonates, blowing the entire company to kingdom come, but Jackson didn't care. If that's what's gonna happen then that's what's gonna happen, 'cause I ain't killing no women. That was all he would say, so it was really stupid for the C.O. to order him and the kid from Wisconsin to take out the two female prisoners; one of them was a sniper but since no one could tell which one, the order came down to dust them both.

As they walked the women out into a wasted field the kid wondered what Jackson was going to do; just sit there while he blew their heads off? He didn't really care, he could do it just like he'd shot squirrels, dogs, and everything else that moved back home. He had this sick ache all the time that he was never gonna see his dad walking across the blueberry fields of Wisconsin again, and as long as that pain was there nothing much mattered to him. But Jackson was real formal about it, he made each one lie down and

then he fired a bullet into the ground next to their heads. It made the kid laugh, you know, like OOPS sorry, guess I missed. When Jackson looked up at him he just shrugged, walked over and did the same thing. The girls understood what the soldiers were doing because they lay in the dirt still as death until well after the two soldiers had walked away.

The kid knew it was a really dumb thing to do. The C.O. was a fanatic and if he found out, forget it. He remembered when Thomson once came back with a prisoner and all hell broke loose. No one could understand how Thomson made it back, much less bringing that toothless old man with him. They both stood there grinning as the C.O. jumped out of the helicopter, walked over to Thomson, blew the prisoner's brains out, then got back in the helicopter just like he had forgotten his hat or something. But the kid was so worn out with killing he didn't much care who got mad.

Later that day the entire company was wiped out. It happened crossing a field. They were pinned down. The only way out was to cross this field littered with land mines. The company spread out, but it didn't matter. One by one everyone they knew was blown up, but they just kept walking. The only two people who made it were Jackson and the kid. They sent the kid home where, snuggled deep in Wisconsin with his blueberry fields pulled up to his chin, he still dreams of that field; it's red just like the sky above it and when he reaches down to turn over a crumpled body, the face under the helmet is always his.

March    *Oil*    48"x 48"    1988

## Reflections

WALKING ALONG the street she carefully watched her image break apart and re-form in the various glass windows and doors of Fifth Avenue. She was always looking at herself in reflections; in restaurants she had to sit with her back to any mirrors to avoid the embarrassment of being caught staring at herself throughout the entire meal. It was not that she was vain; she simply felt that she had no existence other than as a reflection and she had to keep checking herself to make sure she was still there. She was only what people thought of her; if they didn't think of her, she seemed to vanish. Her body would go transparent, she couldn't move her hands or feet, she could only wait in fear for her heart to stop.

It happened in the doctor's waiting room where she had been left alone. At first she was just nervous and didn't feel like moving, then she became aware that she couldn't move, that the chairs had surrounded her in open hostility, and that the coffee table, crouched under its magazines, was keeping her pinned to the couch which moved beneath her like some sleeping monster. Each minute was an hour of frozen terror. By the time the door opened and the doctor held out his hand to her there was a wall of a thousand sheets of glass between them, and his voice was so far away it made someone else in her head start to cry.

Reflection 2   *Oil*   60"x 72"   1989

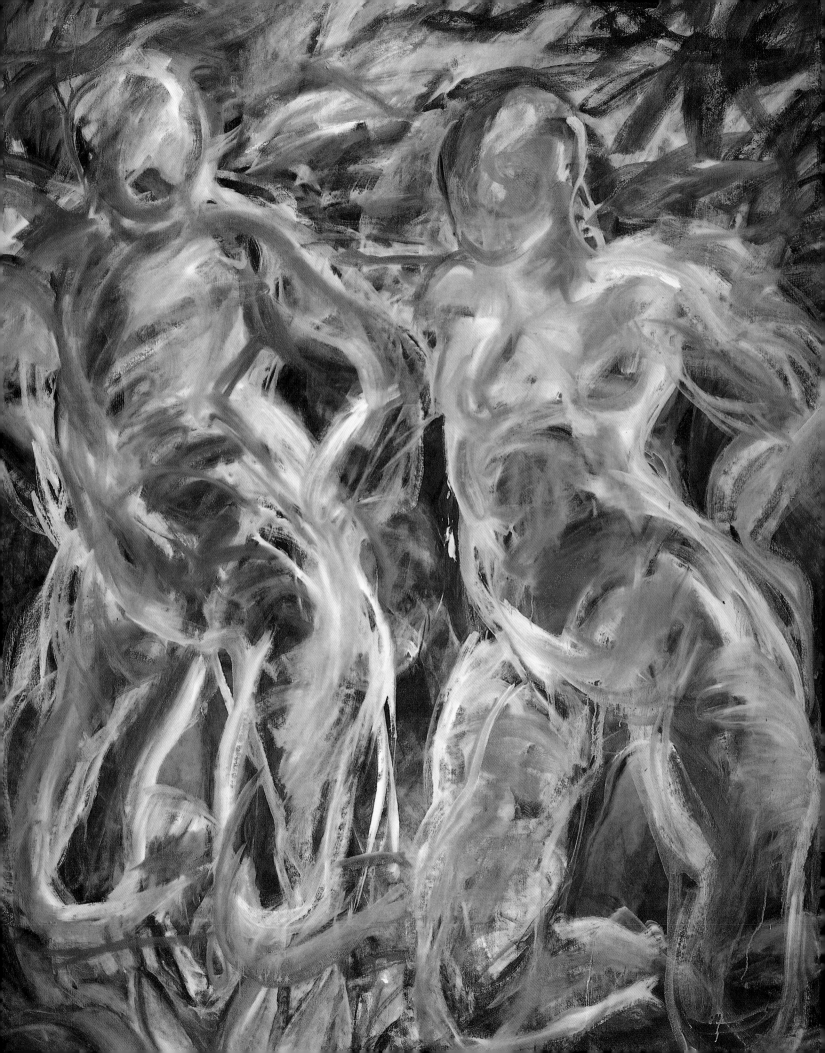

THE LAST ROOM is the one I visit my shrink in.  He says I cannot keep trying on lifestyles as if they were different pairs of shoes, but secretly I think I'm Cinderella; that the next lifestyle will be the one with the "live happily forever after" prize in it, with the Prince Charming doll and the fantasy castle, and that the next room I enter will be the one — the one what?  I

*Rooms*   wonder.  I mean, I met Prince Charming, I dated him, I couldn't stand him, and the only thing I ever got to be in anyone's castle was the receptionist.  When my shrink asked me what my own room looked like I couldn't tell him.  I forgot how I decorated it.  Actually I don't think I ever did decorate it, and I certainly never slept there.  Other people would tell me I lead an interesting life and I would look at them like a hunted animal.  Would you mind telling me which room is my life?  I can't find it.

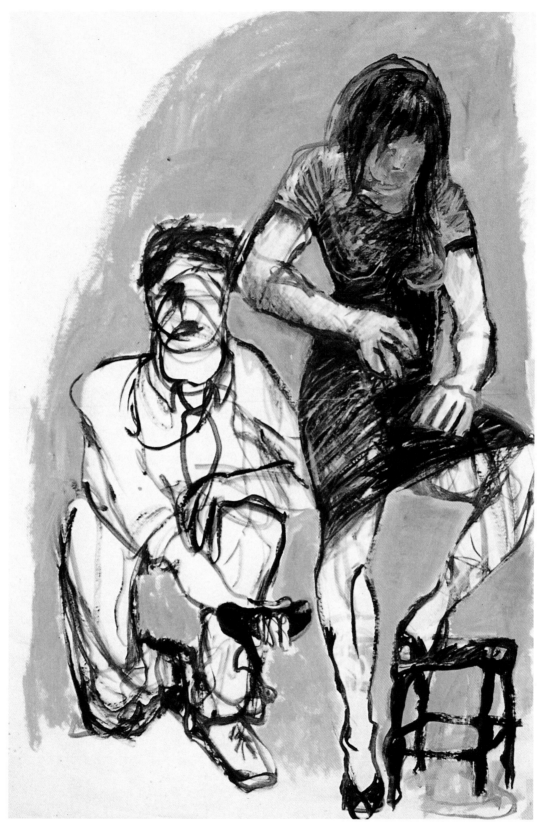

Cinderella    *Acrylic*    42"x 72"    1982

After the shrink helped me find my room I wouldn't stay in it alone.
I brought everybody home, and once they were there I couldn't wait for them
to leave. They would swell up like blowfish so that I couldn't push them out
the door. When I wasn't looking they would leave odd gelatinous markings
on the tablecloth and rug, similar to the snail markings left in the garden at
night. They developed furry odors and anything they didn't understand they
tended to eat. The place was a mess until I threw them all out. Now things
are fine — the carpeting is four to five feet high, the tablecloth lays eggs
regularly, and the dishes have decided not to fly south for the winter — they're
going to stay here with me.

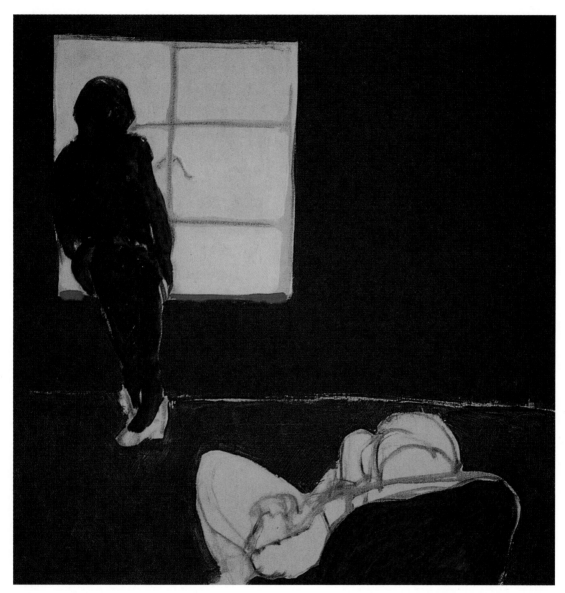

The Room    *Acrylic    8"x 10"*    1981

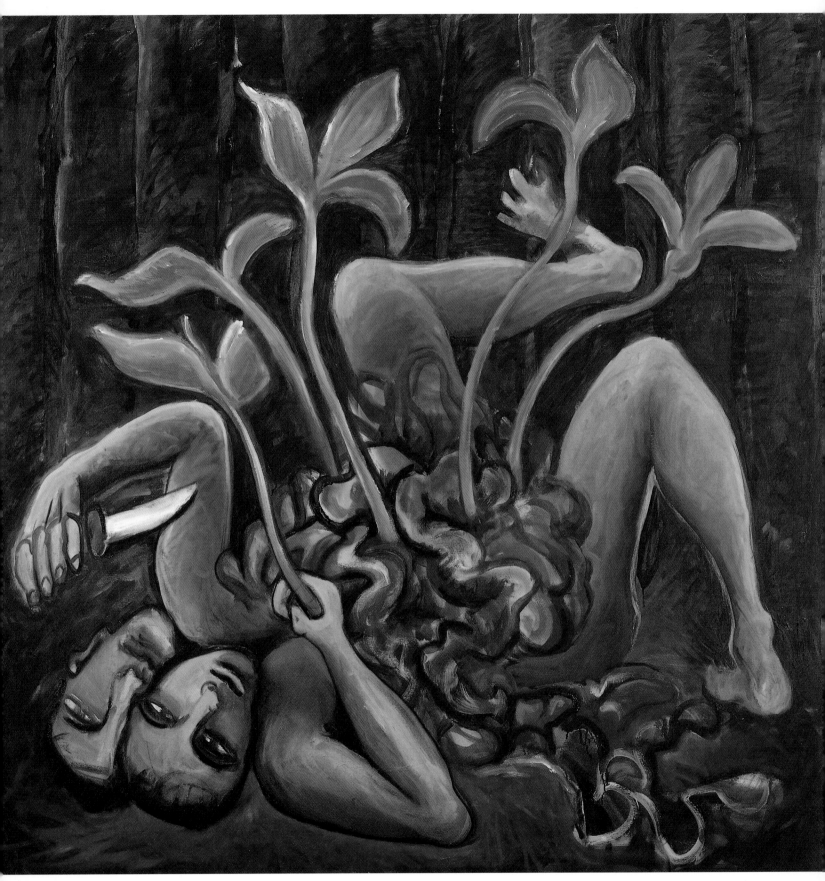

Operation   *Oil*   54"x 54"   1991

THE DOCTOR SAID I would die if I didn't have the operation. I didn't want an operation and so I started to die. There wasn't a lot of pain, I just got weaker, started walking slower, until it became a big deal to even cross the street. I had a party where I lay all dressed up on a couch saying good-bye to

*Operation*

all my friends who thought I was joking because they still lived in that other fast world. Small things became very impressive, like the way the grass stepped out of the dirt dressed in Kelly Green. Used to be I would march through the entire Angeles Crest Forest and think of nothing but losing weight. Now I liked holding on to a certain stone; its gray roundness looked smooth and soft as the back of a mouse, but it felt hard and mysterious as a piece of compressed dinosaur flesh. Watching a bird fly across the empty sky could make me cry. I had never cried very easily before. I began setting up crying experiments — watching a bird while listening to *Mme Butterfly* and smelling a rose from my garden which soon I would never see again. I couldn't bear to see anything struggle on TV or think of the past, like the matching dark blue duffel coats my brother and I wore to school each morning, when we thought the summer would never come. It was too painful; I was a walking oyster without its shell. In a week I was on the phone begging the doctor for my operation.

## Dear Alison,

I think it would be a mistake for you to visit me. As you know, our state has legalized the eating of long pig not just for survival, but pleasure, so there is a tremendous demand. I suppose the farms are better, more organized; at least you're not afraid of someone pulling a knife and fork on you in the street any more. Here they give us plenty of warning so we're not traumatized, which apparently toughens the flesh, and they can't take us before the allotted time provided we keep eating our prescribed amount. (You wouldn't believe how fat I am.) They provide us with everything. I'm much happier than when I was struggling, although I miss not being able to exercise. Still, I don't think it's a good idea for you to see me like this, it's upsetting if you're not accustomed to it. It's not hideous until they come to get us, but don't worry, my due date is months away, three months and seventeen days to be exact. So write me a note when you get this, and don't tell Mom.

*Cannibalism*

Love,
Jennifer-2375877658

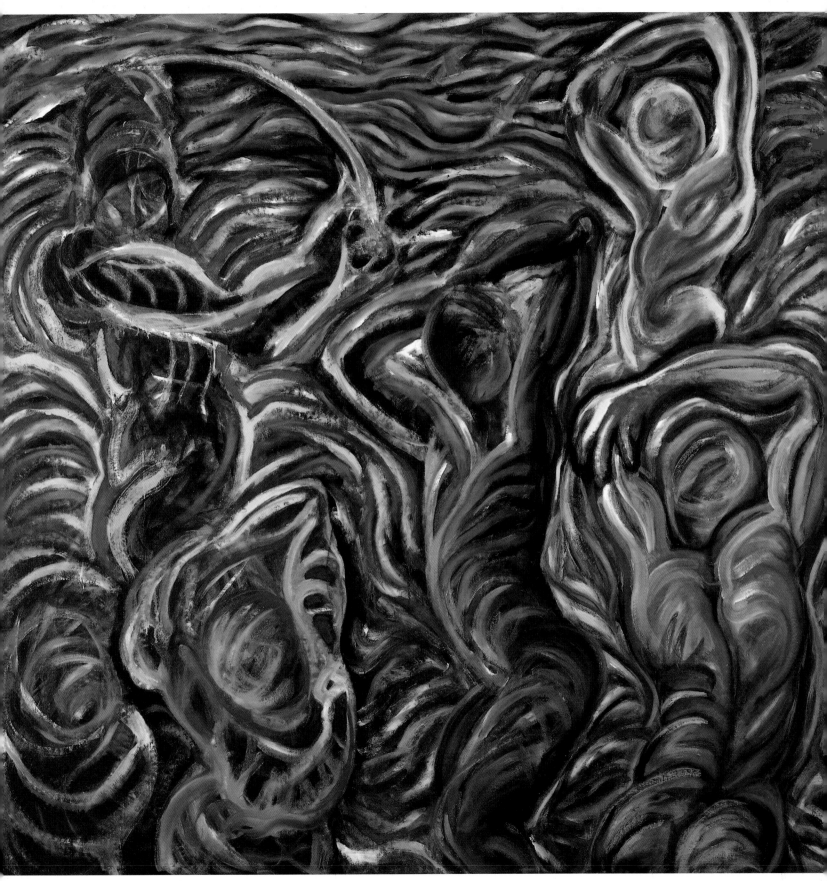

Detention   *Oil   60"x 60"   1988*

Dog Bite (detail)   *Oil   48"x 60"*   1988

# IO

# DOGS

## IN THE

### END

SOME TIME AGO it became the fad to take a running mate you really liked to D-Range and have outdoor sex with them. You could be sure not to be interrupted because everyone knew that D-Range was toxic, no matter what the government claimed. It wouldn't hurt you to spend one night, but nothing lived there except wild dogs and giant tumors that thrived like mushrooms on everything: rocks, tin cans, and the empty ruins. To enter D-Range was illegal, not only because of the levels of toxicity but because sometimes people didn't come back, and nobody wanted to go in there looking for them. Kidnapping by aliens was rumored but we considered the victims lucky even if they had to become slaves or science experiments to escape the present living conditions. These stories, however, did not stop the Children of the Pelt, as Tommy's wing was called; as a matter a fact it just made it more romantic to have the courage to love your mate one night in D-Range, or your drag if you happened to be married. Due to the population problem, D-Range was the only place where you could get any real privacy — to be in that much space and be alone was worth the risk, and not just for lovers either — before they put the fences up the old people used to go there to die in peace.

Tonight Tommy was taking Charlotte. She was the fattest girl in the wing and he was very proud of her. What with the chronic food shortages no one was fat any more, and it was a mystery how Charlotte gained weight. When she was young the other children accused her of tumor eating, which used to hurt her horribly, but when she didn't sicken and die they had to believe her mother who insisted that it was glandular. As she grew up, however, the tables turned — the males found her weight not just an oddity but extremely attractive and Charlotte became the envy of the wing, a position she accepted humbly as she didn't feel she had really done anything to deserve it. Even now she was painfully aware that Tommy had only asked her to D-Range because of her glandular condition. Charlotte liked Tommy, but she was

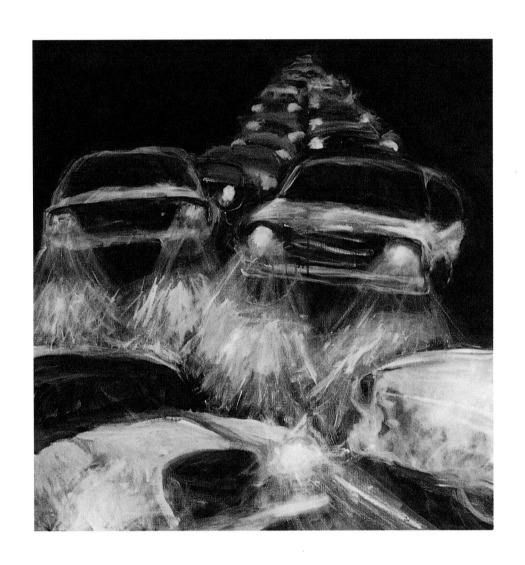

a little afraid of him — he was a very big deal in the wing, mainly because he had one of the few cars that was not just a stationary object. Since all functional buildings were used to house the computers, most people lived in their cars, except on Gridlock Day, when these auto shells were dragged into the streets to be proudly displayed in a static parade. Now the only place where there was enough room to run a car was D-Range. Tommy had been there a lot without showing any symptoms, but then he never got out of the car. Getting out of the car and doing the wild thing was like marriage — you only did it three or four times in your life.

Inside D-Range the car ride was thrilling — so raw, like riding a horse at full gallop across the plains must have been, something Charlotte had only seen on the Howitwas video, although she had seen a real horse in The Specimens House when her Dad was a lab janitor. Speeding under the old freeway structure which loomed out of the wasteland like a runaway cathedral, swerving in between its cement pillars, they took some narcos which Tommy had smuggled out of one of the government labs. Charlotte's fears scattered like minnows across the rippling asphalt. The land and sky were big and empty and Charlotte felt as daring as the old explorers when the world was unknown. When they stopped she jumped out of the car and actually laughed as Tommy quickly removed their clothes. In the middle of doing the wild thing her excitement was heightened by the eerie premonition that her life was in its final few hours, and the idea of never going back made her so happy that she opened her eyes, something she never did during sex, to see Tommy straining above her and the empty sky of Lost Angels that stretched above him, making him look small, and she smiled as he no longer mattered. Her eyes drifted far out to the giddy edge of the world and back again to the pairs of hungry yellow eyes staring at her. She stared back at their patient ears and anticipatory paws quivering in the dust. First there was one, then two, three,

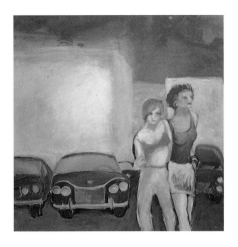

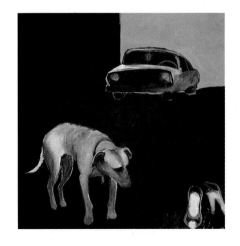

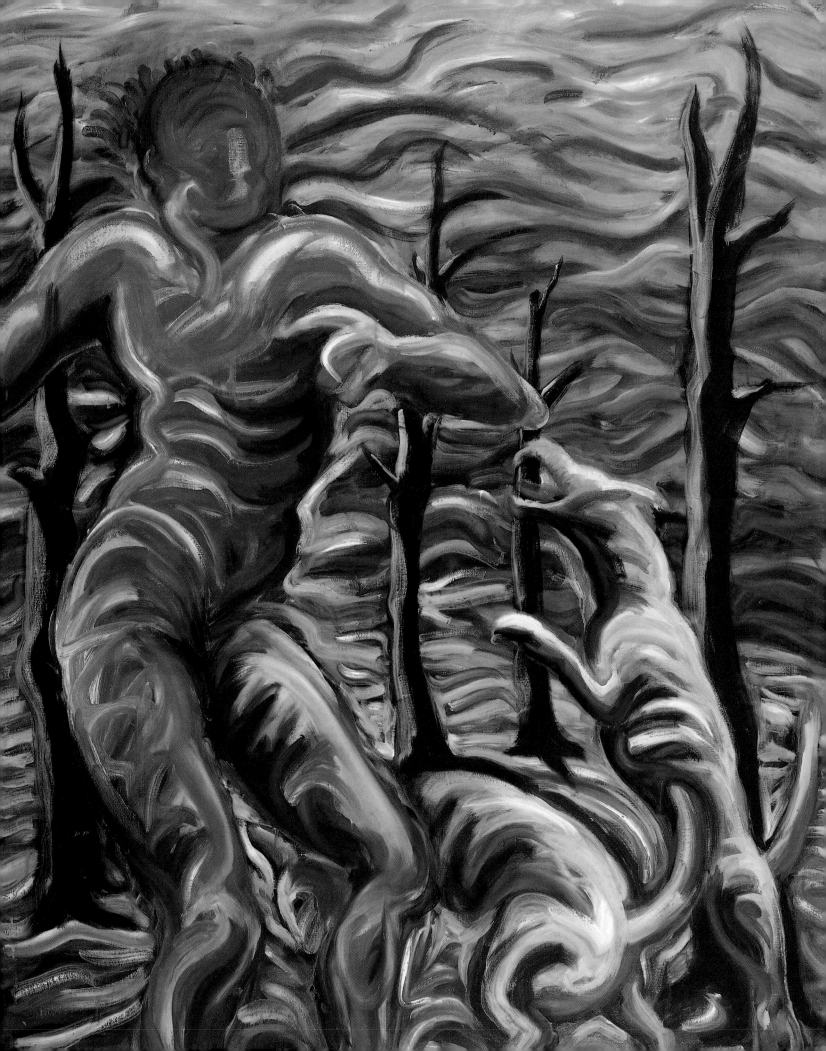

thirteen, and then twenty quietly waiting dogs — part lunatic coyote, part mutated strays come back to murder their masters. Everyone knew about these dogs, about how they had got their taste for humans by eating corpses left in the street. As they crowded closer, smelling like death, Charlotte just continued smiling. There was no hope of her out running them — Tommy would, he was a fighter, but she belonged to those soft black noses and panting pink tongues.

With a loud curse Tommy pulled out of her soft body and pulling on his shoes he yanked her to her feet. The car was on the other side of a field of rubble and baby blue tumors, and they had only reached the middle of it when the dogs cut them off and one by one started circling them, their low growls rumbling the ground. It was obvious that the dogs had the upper hand. There was no way both Tommy and Charlotte could make it to the car, but if the dogs were occupied with one of them, they might let the other escape; and they seemed to be interested in Charlotte. Abruptly Tommy pushed Charlotte to the ground with such determination she did not bother to get up. Covering her face with her arms she waited for the first nose to touch her.

Safely inside the car Tommy did not turn on the engine, not while Charlotte's screams scattered across the wasteland like broken birds. There were a lot of them, and Tommy listened to them all. The first cries rose strong but blind — they shot into the sky and, turning hopelessly, smashed into the ground. Then weaker ones fluttered frantically across the pebbly dirt dragging broken wings, flopping on busted legs. Fucking shit, he thought, why did the damn dogs have to take so long? Why didn't they go for her throat instead of eating a whole leg while she thrashed around helplessly? It wasn't until the sun went down that he finally heard the last weak bird's neck snap in half, followed by a merciful quiet and the happy eating of the dogs. Still Tommy could not go: he sat through the night with the moon shining down on his white car and her two empty shoes.

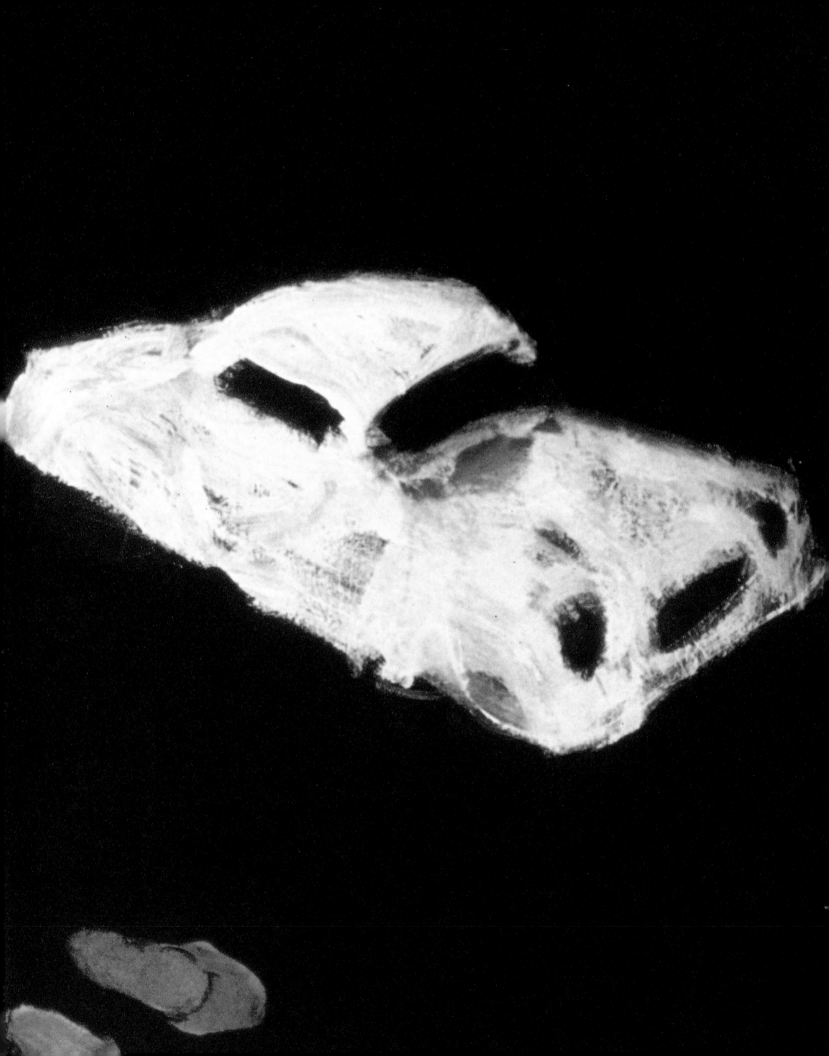

| a | b |
|---|---|
| c | d |
| e | f |

Raymond Chandler's Last Dream  (detail)

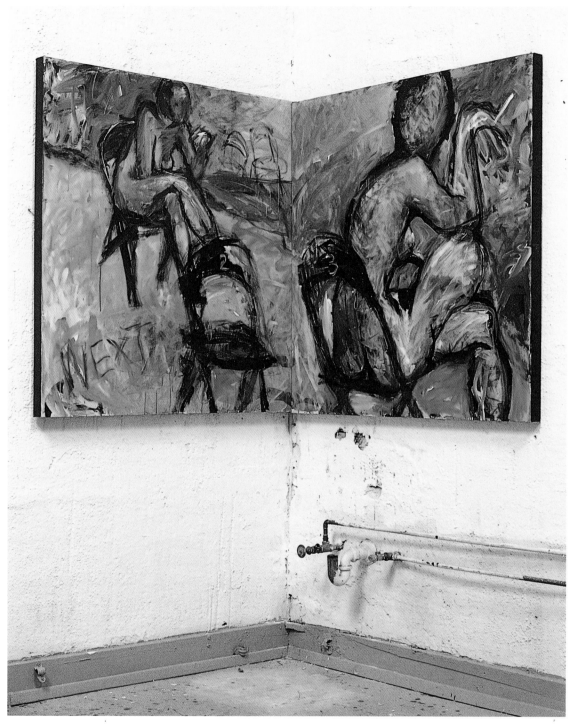

Next   Acrylic   96"x 60"   1981

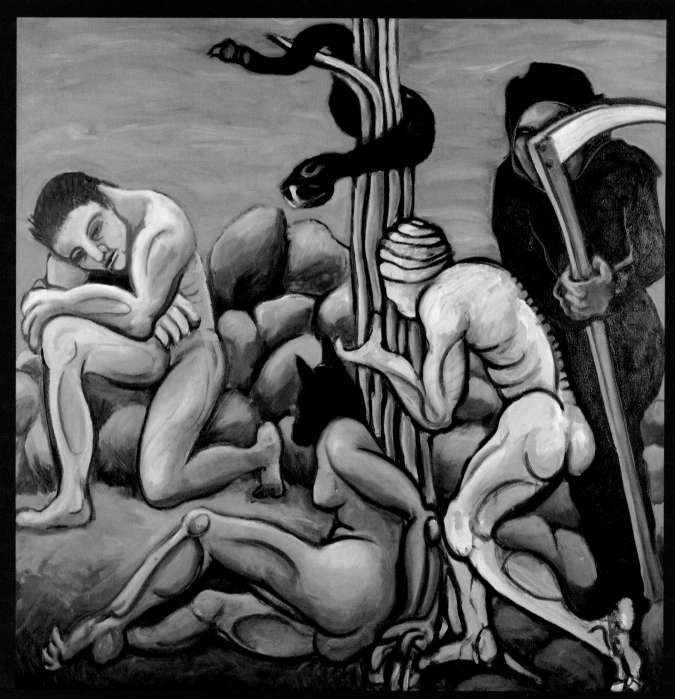

Temptation  *Oil*  54"x 54"  1991